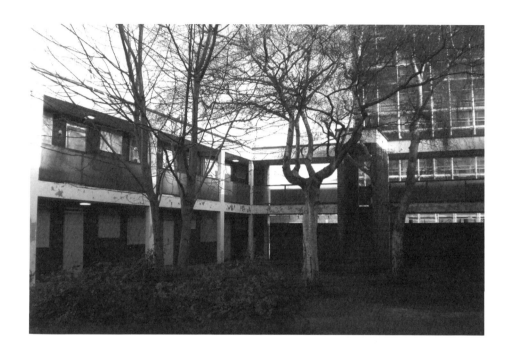

'O world'

'HYPERSENSITIVE' 'The silent' 'Cleansing'

'Dover beach'

'SEED'

Dignity

A mute violence

Parut.

'NEW CONSIDERATIONS'

'THE META-NARCISSIST'

'LIFE IS WITH OTHERS'

under Formal Supervision

'CLEANSED

'Foxhole Farm'

'PASSIVE' 'Moses and Aron' 'SALT LENGTH' 'What is permitted' 'Hakehiho

'PRAXIS'

'THE BIRD'

'WHAT IS PERMITTED'

'IN A DRAINED MOAT' THE CATHEDRAL OF EROTIC MISERY

'Black chance'

'PRANK' 'THE LAWYER' 'EXHAUST'

'WITHDRAWL'

'AMBIGUITY' 'VALE' 'VOID'

'FIRE IS NOTHING WITHOUT ALARM' 'AUTHORITY'

'SKELETAL BELIEFS.'

'LEAD @ ASPIRIN'

'ASCENSION'

'A GROUP OF DEADENED OBJECTS under orders to deaden them further'

'OR COURSE in Desperate Desperate pictures'

'WE WILL WAIT UNTIL ITS NOT IMPORTANT ANYMORE'

'ANEMIA' ' POSTERBOY?'

'Still falls the rain'

* RA

'TRICLINIC'

Hygene!

'Opening in France...'

Indi

chateaux
Rue de.
université

To
VOID
DEI

Marquettes
models

Involuntary twitch of the
seizure
'Genital injury

SAMARITANS 'SYMPTOMS'

COERCION ←

MASS ← 'AWAKE'

THE UNATTACHED ← 'IDIOT'
RESENTMENT.

Eaten from within REJECTION—
 SEAGATE
' I became NORTHTOWN — ' The realisation
an incident on DETATCHED. — of life cycle!
the border - INDUSTRY —
 PREOCCUPATION ←
 RESPECT. ←
 FINISHED. → ' A formalised
 BETRAYAL . — society'

Universals origins of geometry - crystals

Duality

An abstract of machine x 2
with two sole purposes of negation, and through autonucleic perfection.
The System put forwards are the accumulated of the human, based on
sustaining the nature of the human

Through extreme repetition, the fundamental nature of these machines
and systems we can transcend the human frame,

To offer primary site → The inexperiencable of the growth, You are simply a viewer after
To offer dual signs - a complexity that is not singular, a spiritual home
not monotheism, relational, to offer a new set of conditions of experince
a vibration between points. The space Disinherited from material and the social, A cold society perhaps
history has frozen
to offer no sense of conclusion., to get past the spirit of site the chosen status
place. utalitarian in its duality, a relationship oec problematic begins

Terrytremdy, Terror systems
Can there be an extreme that can lead to our deaths if Botched.

A machine exterior to all function than abstraction and autogensis. to aid. to the absolute
Subject, a path towards...

The conditions of experience shift in two rites. We don't discuss the work in
esoteric terms, but others will.
To remember the ritual, removed of faith, to become the compulsive.
System, a compulsive interpretel by as the systems, Grown by
will and necessity to transcend the frame

1. Contact lenses
2. Light bulb (Both images)
3. unfiltered engine (ngrers)
4. unfiltered photo stalk
5. Brisju film
6. Tate fine both images
7. The birth of the architect Front + back
8. Serpentine work 'Benign'
9. fleet st image with me burning the drawn

£67·88p

crystal floor
partial flooding A state of exception

mist. Biopolitics

leaks Listo

leaking vessels + pipes.

(workers)

Seeps and small peristaltic drips.

Rivers falls + streams.

Steam environment, moist oppressive air.

pressure release window (coast to coast)

Security performanec (mixers)

To leave alone?

Drip from above - stalagtites + mites.

Building search

Estate heaters? electric.

(materially condemned)

Dressed ruins.

Indifference as a starting point.

HISTORY IS DEFINED BY SYSTEMS GREATER THAN US
The severity of our will
To the rigorous extreme of consciousness - the limits.
The fragility of the frame of the human against systems and
mechanisms that can do it damage. a negation of ourselves —
is sought either known or unknowingly.
But there is a reversal

Black growth of black mould.

Disinfectant spray

15 minute regulation
Automatic / systom'd. (violent)
and with lack of humanity
Set by us.

To be 'A process to be bigger than us.

A claiming of the environment.

It goes on...

EXCESS procedure
and surplus

For eagles in a polished Beautiful place?
there are material flow.
a new office
So conflucs Isolate
Everything becomes Homogenised

Cooling Crystallisation

The process of cooling crystallisation involves saturating a solution at a given starting temperature and then lowering the temperature so that the solution becomes supersaturated. At a certain supersaturation, dependent on the presence of seeds, temperature etc, the substrate will crystallize, which results in a lowering of the substrate concentration in solution. Therefore to maintain a supersaturated solution the system must be continuously cooled. This results in a 'crystallization trajectory' above the solubility curve, which is described by the variation of the solution concentration as a function of the temperature.

The shape of this trajectory is based on the cooling rate and profile; and the kinetics of nucleation and growth. The natural cooling profile[1] is described below in (1), where T is the solution temperature in °C, T_i is the initial solution temperature and T_o is the final temperature. t is the time in s and τ_B is the batch time in s.

$$(T - T_o)/(T_i - T_o) = \exp(-t/\tau_B)$$ (1)

The batch time is quantified in terms of the mass of solution M_s, the specific heat capacity C_p, the overall heat transfer coefficient U and the area for heat transfer A_B.

$$\tau_B = M_s C_p / U A_B$$ (2)

Equation (3) describes the fall in solution concentration due to the nucleation and growth of crystals. Here c is the solution concentration in g/100g water, k is the first order rate constant in g/(100g water s) and c_{eq} is the substrate solubility in g/100g water.

$$\frac{dc}{dt} = -k \ln\left(\frac{c}{c_{eq}}\right)$$ (3)

Data has been plotted to give a 2nd order polynomial that described the solubility in terms of temperature (4)

$$c_{eq} = 0.004293T^2 + 0.1666T + 15.12$$ (4)

Using a 1st order numerical integration method and a step increment of 1°C, the relationship between c and T has been calculated. Figure 1 shows the trajectory for a thermally and chemically homogenous tank of $CuSO_4$ solution cooling naturally from 70°C to 25°C; using an arbitrary product of the first order rate constant and batch time $k\tau_B$ of 100 g/100g water. The solubility curve for $CuSO_4$ is also shown and a maximum undercooling of 1.4°C has been used to define the metastable zone[2].

Figure 1: Plot showing crystallization trajectory on a solubility plot

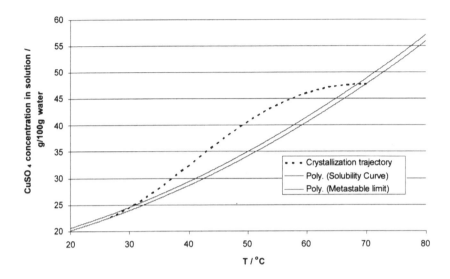

The 'crystallization trajectory' for natural cooling gives a supersaturation which varies considerably with time (N.B. this model makes no correction for the solvent held in the solid phase during crystallization). The trajectory extends far above the metastable zone in this example, which results in spontaneous crystallization of material and high nucleation rates. This may result in a large amount of substrate crystallizing in the solution away from the walls and sedimenting to the floor of the structure. This effect could be reduced by decreasing the cooling rate, by adding insulation for example, thus increasing $k\tau_B$; Or by using smaller changes in temperature, thus scaling down the trajectory. For the problem in question this may not be an issue as the structure will be at ambient temperature when the solution is added. This should cause the crystals to preferentially form on the walls due to the cooling effect of the structure itself.

Calculation for Formation of CuSO$_4$(5H$_2$O) on a Structure

The amount of copper sulphate that is required to saturate the solution at the initial temperature and the amount of crystallite formed on the structure can be calculated by considering the solubility curve. Additional information is required included the density of copper sulphate solutions of differing concentrations[2] as shown in table 1 and the density of solid $CuSO_4(5H_2O)$, where 3604 kg m^{-3} was used[2].

Roger Hiorns Project

- ☐ **Initial areas for feasibility study**

- ☐ **Site General**
 - ☐ How do we come up with a generic example of site to give information needed for chemical assesment? Research
 - ☐ What kind of space is available around site / what is required to actually bring tank into place around a building like this?

- ☐ **Chemistry**
 - ☐ How do we calculate what volume will be taken up by structure, within the tank?
 - ☐ What volume of CS powder into what volume solution do we estimate/know is required to fill the tank? Consult
 - ☐ What level of precipitation can be expected from this volume / temperature / time / concentration of solution?
 - ☐ What weight of crystal growth does this represent? How accurate can we be?
 - ☐ What general problems might we encounter in precipitating crystal growth from this volume of liquid?
 - ☐ What are the considerations for chemicals eco-toxicity in case of leaks?
 - ☐ What general issues surrounding water table/use of chemical in public space should we explore immediately?
 - ☐ And general toxicity (human) of chemical at all stages for which exposure is possible?
 - ☐ What's the degradability of crystals once precipitated (reaction to elements)? Is there a possibility of contamination from this? Assess

- ☐ **Structural (House)**
 - ☐ What are the structural considerations of *statements*
 - ☐ Weight of liquid on walls (internal and external pressure)
 - ☐ Effect of liquid on building over time (soaking of walls etc)
 - ☐ Weight of precipitated crystals on walls, floors, ceilings
 - ☐ What risks of partial collapse/weakening beyond acceptable level for public entrance of either building or the crystal formations
 - ☐ What reinforcement would be needed as a result?
 - ☐ What structural additions would be needed to ensure containment of liquid above ground?
 - ☐ What are the risks of leaks and what would the effects be? (see above re chemical).
 - ☐ What other structural alterations would be required to building site, in terms of access/space etc
 - ☐ What's the orientation of the site in terms of light, access and usage?

 ① Model

 Maths + Volume,

 2 up 2 down

- ☐ **Tank**
 - ☐ What material is the tank to be made of?
 - ☐ What do we estimate size and volume is likely to be?
 - ☐ Is this something available 'off the shelf' or only bespoke fabrication? *prefab. concrete tanks?*
 - ☐ How would the tank be moved into place? How would it be fixed in situ such that it was entirely leakproof.
 - ☐ What access are we designing into the tank construction. What is the possibility of drop down leaves?
 - ☐ If its open at any point, how do we close it to protect from the elements *shutting or simple trap doors.*
 - ☐ Is the tank itself vulnerable to vandalism and how do we avoid that
 - ☐ How is the tank filled. How is it drained? Into what? *Tanks and tanks*
 - ☐ How can the tank be designed to allow light in?
 - ☐ How do we drain the liquid? Where does it go? Will draining damage crystals (speed of drain/ unequal pressure change?)
 - ☐ What are we likely to find once we've drained it in terms of broken materials? Do we clean up/change anything?

- ☐ **Pre-preparation of house** *post, galvanic, reactive , and soggy absorbent it Structural.*
 - ☐ What preparation is required: what needs to be removed, or secured?
 - ☐ Do we need any sort treatment on the walls to make the precipitation optimal? *seeding....*
 - ☐ How do we deal with the floors and will they be walkable afterwards?

 ① 20%s

- ☐ **Re-flooding: feasibility and considerations**
 - ☐ Can we reflood the tank? Is there anything in the design that prevents this possibility?
 once built the tank should be capable of re filling till
- ☐ **In process: sealed (precipitating)** *we require it no more. It should be post but simple* *as it needs to hold pressure*
 - ☐ Do we protect the tank? How? Are any staff needed/security? *on all sides and be leak proof.*
 - ☐ Is the process in any way visible? *Just through monitory eqpt + vapor*
 - ☐ What access can we leave to check how things are going? *as above thermocouple + visual recording.*
 - ☐ Is there any information to be provided? *underwater cameras pin hole with a growth attch*
 - ☐ At this stage are we interested in public engagement? *to be decided with ptc.*

 26th 28th NOW

- ☐ **Running: crystallised**
 - ☐ How do we open and close the site/building? During what timeframe? Daily?
 To be decided with reslt. but daylight light hrs. perhps

 2 oclock Tuesday

① The volume of a house.

① The weight of additional material. to water.
in Solution supersaturate.

① The liquid volume of a space as equation.

Process. a recording device - as continuation of form made visible.

'celibate' machines - Duchamp ~~la mariee mise~~ The bride...

Kafkas penal colony,
Roussell machines and Jarry, even those of poe,
all full of earlier tortures, and ancient laws of physics and distribution.
paranoiac machine. each manifest the difference and the new in its production.

A Transfiguration ~~by~~ the machine that cannot easily be explained. (unger)
through hyper production. A dictatorship of no alternatives (just spray)
a full mobilisation of resources.

 Trapped within
A human web of growth.

Elementary forms of religious life. _____

invocation of the divine are in fact invocations of Society, the force that
makes human nature effective in the first place.
Becoming more godlike is something like plural Socialism, or the
~~altruism of the newer economies~~.

 one
mark - the genuine human essence remains of ~~the~~ forced makeshift. of
improvisation made natural by a magic of collective will, towards the unexpected.
favouring the founding of new territories rather than the perpetuation of familiar ones.

 it with
Automatic ! an return to the repressed - consuming space to replace multi surface
a delirium of repetition (The building)
 . I am becoming - a god!

 important.
Benjamin - all art has its origins in the ritual.
 ^

System or the aplication of a program, an eternal return.

material emmotion. there is only desire and the Social
 ~~so here are the two together~~

 The social, living in compamites and organised community.
 concerned with the relations of humans.
 The
last social realism

 REAL
THE EFFECTS OF MACHINES NOT MERE METAPHORS
 ^

Reyner Banham

Brutalismus
in der Architektur

dokumente
der
modernen
architektur
herausgegeben
von
jürgen
joedicke
im
karl krämer
verlag
stuttgart

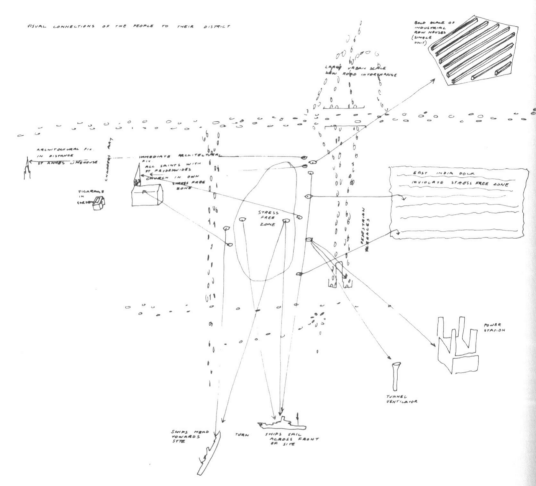

Robin Hood Gardens. Diagram of the stress-free zone, an area of quietude in the centre amidst surrounding traffic routes; note the visual connections to neighbouring features. AS.

Robin Hood Gardens. Photograph of the central green mound: the stress-free zone, an area of quietude. PS.

Robin Hood Gardens. Photograph of the central green mound during school holidays. Sandra Lousada.

It was the intention from the beginning to give as much green space as possible to the central 'stress-free zone' in the form of a protected area, shielded from urban traffic yet open to surveillance from the surrounding flats.

The demolition and excavation materials were not removed off-site, but placed, instead, in the central mound, making it as big as it came.

Perhaps for the first time, many of the people in the dwellings on the ground could look out of their windows at a slope of rising grass—a remarkable experience for Londoners.

TOWER BLOCK CHEMICAL FALL

T 1
W 2
T 3
F 4 ○
S 5
S 6
M 7
T 8
W 9
T 10
F 11
S 12 ◐
S 13
M 14
T 15
W 16
T 17
F 18 ●
S 19
S 20
M 21
T 22
W 23
T 24
F 25
S 26 ◐
S 27
M 28
T 29
W 30

October

T 1
F 2
S 3
M 5
T 8
S 10
S 11
M 12
T 13
T 15
F 16
S 18 ●
M 19
T 20
W 21
T 22
F 23
S 24
S 25
M 26 ◐
W 28
F 30
S 31

MAIN
CRYSTAL
GROWTH

RESIDUE
FLOW
DOWNWARDS
INTO
BUILDING

TOWER BLOCK
LIQUID FALL

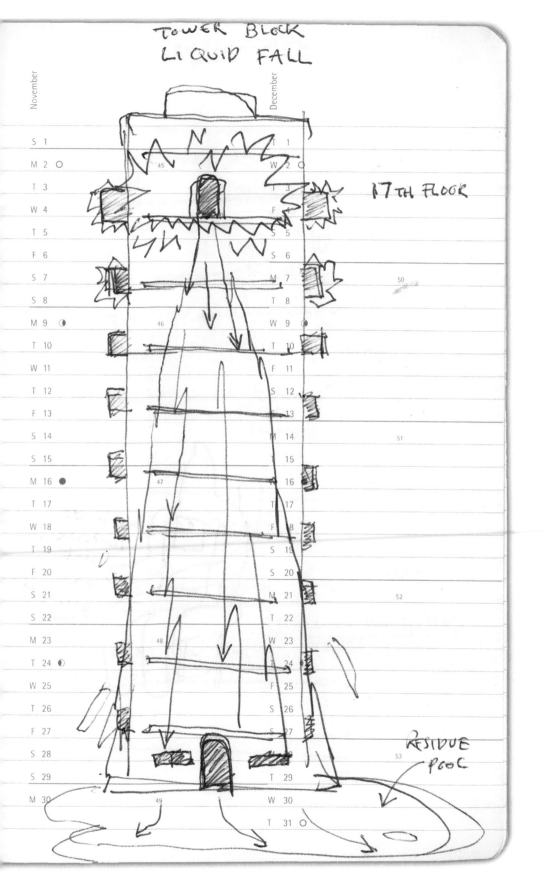

17TH FLOOR

RESIDUE POOL

S 1
M 2 ○
T 3
W 4
T 5
F 6
S 7
S 8
M 9 ◑
T 10
W 11
T 12
F 13
S 14
S 15
M 16 ●
T 17
W 18
T 19
F 20
S 21
S 22
M 23
T 24 ◐
W 25
T 26
F 27
S 28
S 29
M 30

T 1
W 2 ○
T 3
F 4
S 5
S 6
M 7
T 8
W 9 ◑
T 10
F 11
S 12
13
M 14
T 15
16
T 17
F 18
S 19
S 20
M 21
T 22
W 23
T 24 ◐
F 25
S 26
S 27
28
T 29
W 30
T 31 ○

45
46
47
48
49
50
51
52
53

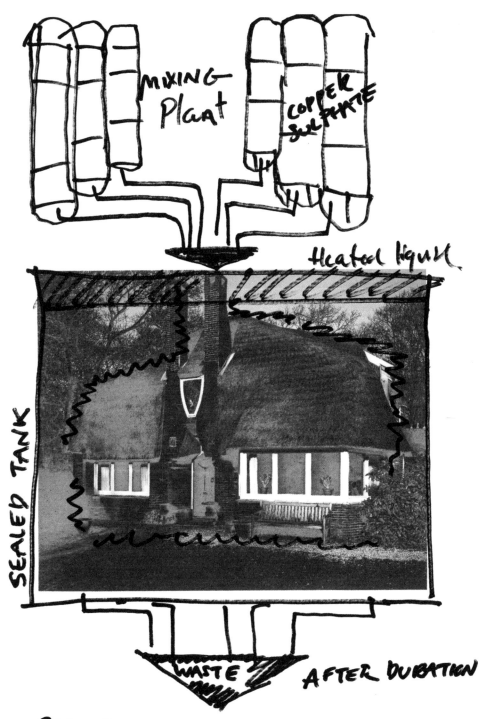

MIXING Plant

COPPER SULPHATE

Heated liquid

SEALED TANK

WASTE

AFTER DURATION

REPEAT.:.

MAYBE

01/01/2008

THE CANCER OF POPLAR.

THE PURCHASE OF A FLAT IN ROBIN HOOD ESTATE,

THE FLAT WILL CONTAIN THE CONTINUOUS GROWTH OF
CRYSTAL SURFACES,

GROWTHS ON THE INTERIOR AND ON THE RELEVANT SELECTED
OBJECTS BROUGHT INTO THE FLAT.

A MERZBAU CRYSTAL GROWTH WITHIN, AND ON, THE SUBSTANC-
OF THE ENTIRE FLAT,

ROBIN HOOD, ON THE EDGE OF THE CITY, WILL CONTAIN
GROWTH OVER A CONSIDERED TIME, AND WILL BE SUBJECT
TO A CONSTANT CHANGE. A BENIGN GROWTH IN LONDON
AND A QUIET ACTIVITY IN THE TRANSFORMATION OF FORMS.

COORDINATES

BRUTALIST,

EMIGRÉ INTEGRATION.

EMERGENCE LANES OF BLACKWALL TUNNEL, IN THE SHADOW
C WHARF, AND IN THE LANDING PATH TO CITY AIRPORT.

http://www.chemicalplaz.com/

http://www.controlspecialists.co.uk/

Analysis and translation
http://chemicals.etacude.com/c/copper_sulfate2.php

http://www.cheresources.com/indexzz.shtml

http://www.cimt.plymouth.ac.uk/

http://www.iso.org/iso/home.htm

Solubility tables.

http://encyclopedia.farlex.com/_/viewer.aspx?path=hut&name=c024
27.jpg

http://www.cda.org.uk/megab2/general/useofcu/copper.htm

http://www.wpbschoolhouse.btinternet.co.uk/page01/AqueousChem/
solubility.htm
http://64.233.183.104/search?q=cache:goLdCwA9iKoJ:www.coe.uh.e
du/texasipc/units/solution/crystals.pdf+solubility+graph+for+copper+
sulphate&hl=en&ct=clnk&cd=10&gl=uk

Tank

http://www.munsch.de/

http://www.plastomatic.com/

http://www.chemresist.com/products/tanks/mixing.html

http://www.braithwaite.co.uk/pages/products.html

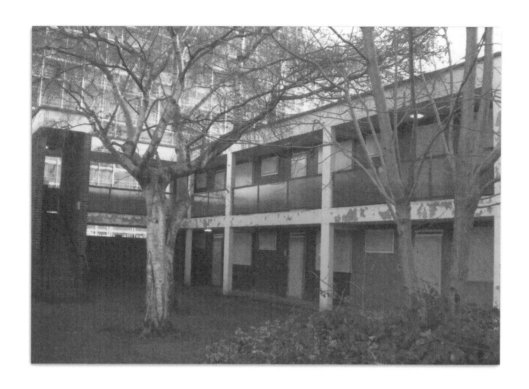

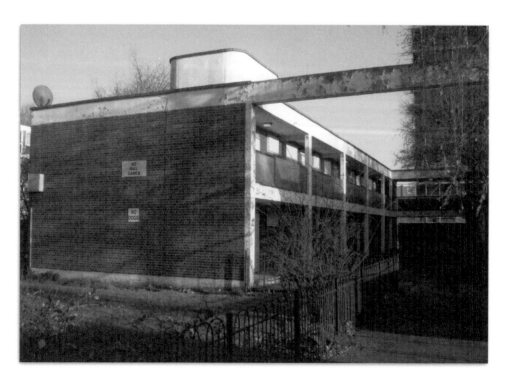

EXISTING BUILDING - PROPOSED SECTION → SUSPENDED SLAB

200mm THICK COPPER
SULPHATE CRYSTALS

STEEL BEAMS BELOW
EXISTING TIMBER JOISTS
TO SUPPORT DEAD WEIGHT
OF COPPER SULPHATE CRYSTALS.
BEAMS ON MASS CONCRETE
PADSTONES INTO WALL

→ FRAME NOT REQUIRED
IF EXISTING BUILDING
IS CONCRETE

ASSUMED EXISTING MASONRY
AND TIMBER BUILDING

SUSPENDED SLAB TO SUPPORT
DEAD WEIGHT OF FULL TANK.
SITE INVESTIGATION REQUIRED
TO CONFIRM

REINFORCED CONCRETE GROUND
BEAMS, ASSUME 400 × 400

ELEMENT OF UNDERPINNING
TO EXISTING STRUCTURE

TANK STRUCTURE SUPPORTED
ON PILES TO SUIT EXISTING
BUILDING → ENSURING BOTH
STRUCTURES MOVE TOGETHER

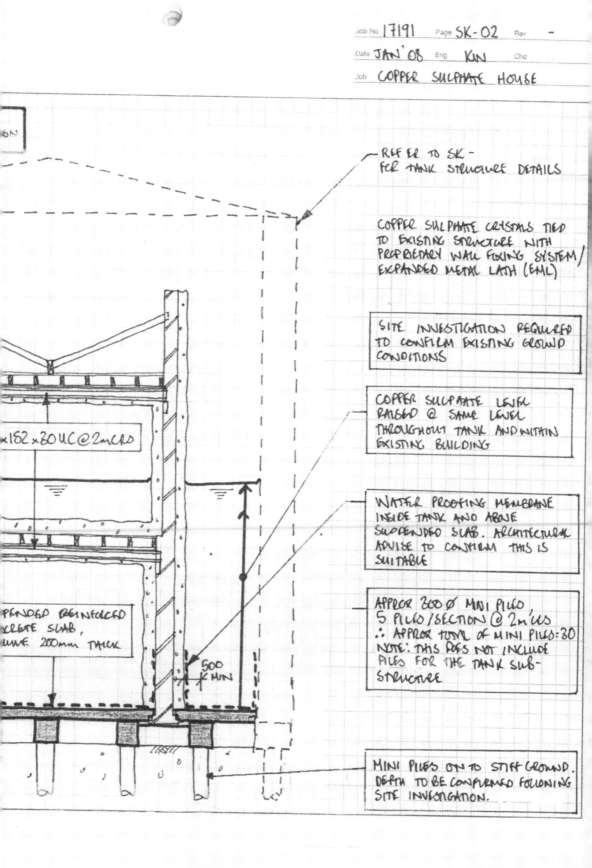

— REFER TO SK —
FOR TANK STRUCTURE DETAILS

COPPER SULPHATE CRYSTALS TIED
TO EXISTING STRUCTURE WITH
PROPRIETARY WALL FIXING SYSTEM/
EXPANDED METAL LATH (EML)

SITE INVESTIGATION REQUIRED
TO CONFIRM EXISTING GROUND
CONDITIONS

COPPER SULPHATE LEVEL
RAISED @ SAME LEVEL
THROUGHOUT TANK AND WITHIN
EXISTING BUILDING

WATER PROOFING MEMBRANE
INSIDE TANK AND ABOVE
SUSPENDED SLAB. ARCHITECTURAL
ADVISE TO CONFIRM THIS IS
SUITABLE

APPROX 300 Ø MINI PILES,
5 PILES/SECTION @ 2m'CS
∴ APPROX TOTAL OF MINI PILES: 30
NOTE: THIS DOES NOT INCLUDE
PILES FOR THE TANK SUB-
STRUCTURE

MINI PILES ON TO STIFF GROUND.
DEPTH TO BE CONFIRMED FOLLOWING
SITE INVESTIGATION.

x 152 x 30 UC @ 2m CRS

SPENDED REINFORCED
CRETE SLAB,
UME 200mm THICK

500
MIN

29 000 kilo

① Strengthening / Underpinning of Building / Prepara

② Copper Sulphate Arrives - stored on site in Container

③ Preparation for mixing facilities in flats an

④ Mixing equipment arrives / assembled (inc heating

⑤ Water arrives / ~~Ice~~ ?

⑥ Mixing

⑦ pumping

⑧ Dam ~~Pumping back to mixers~~

⑨ Drying ← collected by

⑩ Repeat

Equipment

Generator ?

Steam Heating / Mixing

Pump

or 2 × 55000 ℓ!

wall off. 1 2

CS
26 storage

312.

platform

1 flat = 103391. ℓ

↑ void

N B A
close A
mixed +
the less

Delivery area.
Tanks etc

...on of mixing area

...or in flats

...e where

...riment?

Process: Either continual flow ✗ or bulk

Mixed off site?
/ order xl hot cs

Storge
Ground floor flats

Knock out Remove Trees ✗

Crane in mixing kettles

② ⑥ ⑤ ④

Draining →

Tanker to...
(NISP)?

Trace Heated Pipe

...no
...t loss.

Either off site
On site but in court yard
on site Inside

Seperation of mixing area

Pumping?

Out lived to cover one hopes to fill in 10cm growth

Need kW

stn spec

Mae an decomissioning

+ Void farmer.

BASIC TANK WITH EXITS 'CUT OUT POST GROWTH' WALL

Filling area and pumping

EXIT
VALUE
2

WINDOW

Exit Value
1 ←

← potential exit 2 ←

← CUT OUT POLY RROP SURFACE .

ARE SIMPLY POLY WITH MESH OUTERS, SPACED →

it aperture / Down pipe or possible Ladder access in emergency... SIMPLY HOLE IN OVERHEAD MESH.

WALL → CONSTRUTION

Front Door Reversed outwards

CUT HOLE. AREA UNMESHED + WITH POLY PROPELENE SURFACE FOR ZERO GROWTH

Collar steel or stainless to perhaps 'tidy' cut hole.

IN OR OUT

outside

manica S.p.A.

PRODUZIONE DI SOLFATO DI RAME - POLTIGLIA BORDOLESE - ZOLFI - SOLO ELEMENTI E PRINCIPI ATTIVI NATURALI PER L'AGRICOLTURA, LA ZOOTECNIA E L'INDUSTRIA

dal 1948

Sede Sociale e Stabilimenti:
Via all'Adige 4 (loc. Borgo Sacco)
38068 ROVERETO (Trento) - Italia

Telefono: (+39)-0464-433705
Telefax (+39)-0464-437224
Casella Postale 215
E-mail: info@manica.com - www.manica.com
Capitale Sociale € 515.000,00 int. vers.
Iscrizione n. 983 al Tribunale di Rovereto
C.C.I.A.A. Trento n. 79197
Codice Fiscale e Partita I.V.A. 00125080226

TO WHOM IT MAY CONCERN

HUDSON'S GENERAL - USA - 1855

Rovereto,

Re.: Copper Sulphate Pentahdyrate

Dear Sirs/Madame,

We herewith are pleased to give you a small presentation of our main product: COPPER SULPHATE, mentioning all types and packing available.

Any other details: price, specification, sample, can be provided on specified request.

We are the leading western European manufacturer of this product, destined to all applications (all types are manufactured here) since 1948. Applications such as: agriculture/animal feed/industrial applications.

Please choose the best type/crystal size, for your market application, among ours:

1) "Big" large crystals ("stones") as water treatment/agrochem.pest.;
2) "Grain" medium crystals ("coffee beans") as fertilizers/mining/plant nutr.;
3) "Minute" small crystals ("rice") as wood preservatives/dyestuffs;
4) "Snow Technical" microcrystals ("sugar") as electro-plating/pharmaceutical;
5) "Snow F.F.G." microcr., Free Flow.Grade ("sugar")
6) "Snow For Animal feed Industry" micr., Free Flowing Grade ("sugar")
7) "Snow H.P.G." microcr., High Purity Grade ("sugar") as electronic chemical.

Price is the same for all first 6 types of standard production. Last one is sold with over-premium (special grade; non continuos production).
Copper content is always the same: 25% guaranteed minimum. Purity is 98/99% except for the Snow technical Grade" for which 99/100% can be guaranteed (Snow H.P.G.: 99,5% min.).

COPPER SULPHATE PENTAHYDRATE is available within the following packing: bags of 25 , 10 and 5 Kgs net and 50 lb. All bags are palletized, for delivery by trucks, by containers (20'), or by railway's wagons. Big-bags of 1.200, 1.000 or 500 Kgs are also available for the "Snow FFG" (Free Flowing Grade). We can also load in bulk with silo trucks.

Yours faithfully,
Walter Chiaseta - commercial export manager

BEHÄLTER KG
II. Quartal 2008

Thalenhorststr. 15 A
28307 Bremen
www.behaelter-kg.de

Tel. (04 21) 34 690 34
Fax (04 21) 34 690 36
mail@behaelter-kg.de

Seite 2-14: gebrauchte Behälter
Seite 15+16: werksneue Behälter, Container + Rührwerke

Besuchen Sie uns doch mal in Bremen
Wir haben z.Zt. 1.400 Behälter auf Lager

Wir **kaufen** auch Ihre Behälter – auf Wunsch in Eigendemontage.

Werksneue Behälter aus Edelstahl

Baumustergeprüfte Druckbehälter liegend oder stehend
"Druckbehälterordnung AD/HP" –beidseitig geschweißt –

Inhalt cbm	Druck bar	Ø mm	H/L mm	gestrahlt + grundiert	verzinkt
1	11	800	2.260	690,–	920,–
1	16	800	2.260	870,–	1.100,–
1,5	11	1.000	2.200	1.150,–	1.540,–
1,5	16	1.000	2.200	1.370,–	1.770,–
2	11	1.100	2.470	1.320,–	1.770,–
2	16	1.100	2.470	1.740,–	2.170,–
3	11	1.250	2.760	1.770,–	2.400,–
3	16	1.250	2.760	2.130,–	2.690,–
4	11	1.400	3.070	2.770,–	3.580,–
4	16	1.400	3.070	3.060,–	4.150,–
5	11	1.600	2.950	2.910,–	3.870,–
5	16	1.600	2.950	3.270,–	4.320,–
6	11	1.600	3.450	3.620,–	4.790,–
6	16	1.600	3.450	4.370,–	5.930,–
7	11	1.600	4.000	4.200,–	5.400,–
7	16	1.600	4.000	4.900,–	6.430,–
8	11	1.600	4.450	4.510,–	5.860,–
8	16	1.600	4.450	5.290,–	7.010,–
9	11	1.600	5.000	5.030,–	6.560,–
9	16	1.600	5.000	5.790,–	7.880,–
10	11	1.600	5.450	5.210,–	6.770,–
10	16	1.600	5.450	6.230,–	8.470,–

– Preise in € ab Werk

DIN-Behälter unter- bzw. oberirdisch

Inhalt cbm	Ø mm	L mm	einwandig DIN 6608/1 DIN 6616/1	doppelwandig DIN 6608/D DIN 6616/D
1	1.000	1.500	1.410,–	2.230,–
3	1.250	2.670	1.820,–	2.670,–
5	1.600	2.750	1.930,–	2.790,–
7	1.600	3.750	2.170,–	3.110,–
10	1.600	5.350	2.760,–	3.920,–
13	1.600	6.950	3.380,–	4.770,–
16	1.600	8.550	4.210,–	5.810,–
10	2.000	3.770	3.110,–	4.270,–
13	2.000	4.550	3.910,–	5.230,–
16	2.000	5.500	4.310,–	5.900,–
20	2.000	6.870	4.660,–	6.400,–
25	2.000	8.420	5.450,–	7.450,–
30	2.000	9.970	6.610,–	8.880,–
20	2.500	4.550	5.060,–	7.190,–
25	2.500	5.550	5.820,–	8.400,–
30	2.500	6.710	6.880,–	9.690,–
40	2.500	8.700	8.250,–	11.840,–
50	2.500	10.680	9.280,–	13.510,–
60	2.500	12.650	10.910,–	15.640,–
40	2.900	6.650	9.610,–	13.020,–
50	2.900	8.150	11.560,–	15.540,–
60	2.900	9.585	13.050,–	17.260,–
80	2.900	12.750	15.220,–	21.450,–
100	2.900	15.895	17.700,–	25.020,–

– Preise in € frei Baustelle –
(Deutschland)

DIN-Behälter auf 4 Rohrfüßen bzw. Fußring

Inhalt cbm	Ø mm	H mm	einwandig DIN 6618/1	doppelwandig 6618/D
5	1.600	3.320	3.070,–	4.090,–
7	1.600	4.310	3.320,–	4.790,–
10	1.600	5.905	3.970,–	5.090,–
13	1.600	7.500	4.610,–	6.170,–
10	2.000	4.340	5.150,–	6.060,–
13	2.000	5.115	6.010,–	7.610,–
16	2.000	6.070	6.430,–	8.340,–
20	2.000	7.440	6.690,–	8.720,–
25	2.000	8.990	7.490,–	9.850,–
20	2.500	5.120	8.070,–	10.620,–
25	2.500	6.150	8.880,–	11.680,–
30	2.500	7.310	9.990,–	13.340,–
40	2.500	9.280	11.390,–	15.620,–
30	2.900	5.600	11.510,–	14.830,–
40	2.900	7.200	13.820,–	17.900,–
50	2.900	8.700	15.890,–	20.680,–
60	2.900	10.185	17.480,–	22.580,–
80	2.900	13.320	19.740,–	27.120,–
100	2.900	16.455	22.360,–	31.050,–

– Preise in € frei Baustelle –
(Deutschland)

12 Edelstahl-Container auf Vorrat gefertigt

2 x IBC mit UN-Gefahrgutzulassung
Verp.gr. II+III/GGVS-GGVE-GGVSee/ADR-RID A.6
– 995 Liter
– 1.4301
– 1,12 x 1,12 m
– Höhe 1,45 m
– V2A Kugelhahn 2" mit V2A Kappe
– Mannloch 400 mit Schnellverschluß
– V2A Sicherheitsventil 0,5 bar für Entlüftung
– 2" Belüftungsstutzen mit V2A Kappe
– verzinktes Gestell
– 4-seitig unterfahrbar
– im vollen Zustand 1:1 stapelbar
– Prüfzeugnis
– Lager Bremen
– € 1.585,–/Stck.

Alternativ **nach Fertigungsauftrag**
in obiger Ausstattung

	1.4301(V2A) €	1.4401(V4A) €
500 Liter	1.475,–	1.760,–
750 Liter	1.550,–	1.865,–
995 Liter	1.630,–	1.990,–
1.250 Liter	1.810,–	2.350,–
Aufpreis für 11851-Hahn	€ 20,–	

– sofort verfügbar –

10 x Stapelcontainer
– 1.000 Liter
– 1.4301
– 1,12 x 1,12 m
– Höhe 1,48 m
– V2A Kugelhahn 2" mit V2A Kappe
– Mannloch 400 mit Schnellverschluß
– Anschluß DN 50 auf ML-Deckel
– Be- und Entlüftungsventil m. V2A-Haube
– verzinktes Gestell
– 4-seitig unterfahrbar
– im vollen Zustand 1:1 stapelbar
– Lager Bremen
– € 1.510,–/Stck.

Alternativ **nach Fertigungsauftrag**
in obiger Ausstattung

	1.4301(V2A) €	1.4401(V4A) €
500 Liter	1.405,–	1.680,–
750 Liter	1.460,–	1.760,–
1.000 Liter	1.555,–	1.860,–
1.250 Liter	1.630,–	1.970,–
1.500 Liter	2.000,–	2.440,–
Aufpreis für 11851-Hahn	€ 20,–	

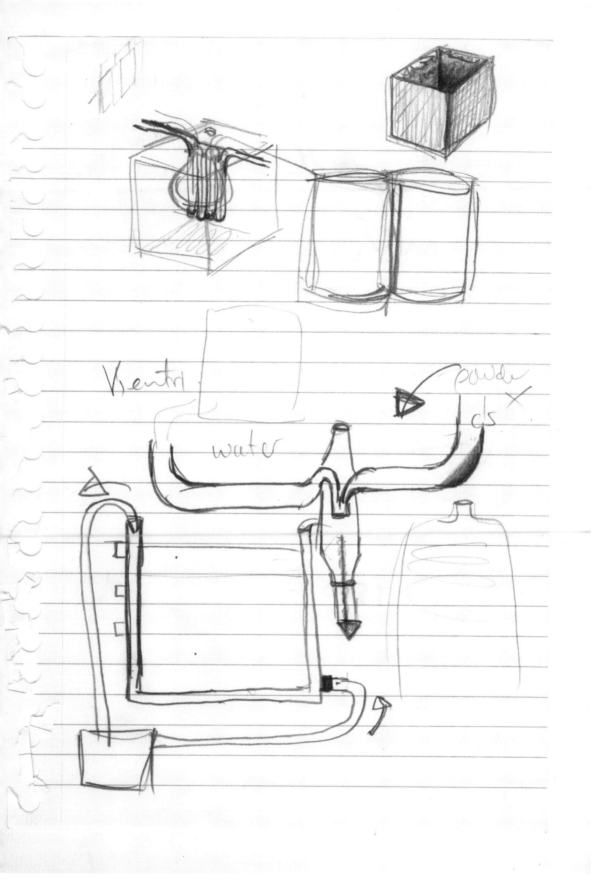

Venturi powder

water X

 cls

NO GALVANISED.
NO CONTAMINANTS

COATING
ENCASING

REINFORCEMENT

LIQUID
RELEASE
VALUES

STRUCTURE

UNDERPIN
PLINTH

PURIFIED

goo ?

SPRAY
FORM ?

SUBSTRATE ?

MATERIALS ABRASION
RATES

CONCRE

SILICONE

COMMUNICATION
OF
REACTING
MATERIALS

ADVANCED
ADDITIVES

SEEDING

object

CLEAN UP
OF HOUSE.

SAFETY
CODE

SAFETY

MASKS

THERMO
COUPLES

LEVEL OF RISK

MONITORING
AND FEED BACK
EQPT

RULES

gloves

SUITS

CONDITIONS

SEEDING
SUBSTRATE

SOURCE
MANICA
MIXING

PLANT

LIQUID
DELIVERY

SUPPLY
WHATS NEEDED.

OFF THE SHELF ?

SOLUTE
MANUFACTURE

TEMP
CRITICAL

BOILING WATER

- Platework
- DECONSTRUCTIVE
- WRECK'
- SUBTLE
- REVELATION
- SPRAYCRETE
- PLASTIC
- REMOVE (SOCKETS)
- TANK
- TRYING THE OF METHOD
- STEEL.
- CRYSTALLINS THE EYES MADE FROM THE SAME MATERIAL?
- The Book
- EVOLUTIONARY BIOLOGIST.
- EVERYTHING.
- ACCEPTABLE PERSONAL COMMITMENT
- OPEN RELATIONSHIP IN WORK ROLES
- DOCUMENTARY
- TELEPHONE
- EVOLUTIONARY PHILOSOPHER
- LABOUR STAFF ORGANISATION
- CLEANING.
- PILOT PROJECT
- MIXERS
- SEEDERS
- ROGER DAVEY.
- CONTINUOUS ANALYSIS
- CRYSTALLOGRAPHERS
- SERVICE SYSTEM ORGANISER
- TIMERS
- SONAR LEAK
- VOLUNTEERS
- VISUAL CAMERA DOCUMENT.
- INDUSTRIAL CHEMIST
- PEOPLE NEEDED.
- SAFETY
- SUPPLY CHAIN.
- INVESTIGATION OF SITE
- REINFORCEMENT SUPPLIES.
- STRUCTURAL ENGINEERS
- WASTE MANAGEMENT
- COPPER SULPHATE
- MANICA TRENTO.
- DISPOSAL AGENT.

ROGER HIORNS
SEIZURE
151–189 Harper Road, London SE1
3 September – 2 November 2008

*Commissioned by Artangel and
the Jerwood Charitable Foundation*

*Supported by the National Lottery
through Arts Council England*

CONTENTS

FOREWORD

Two years ago, Artangel and the Jerwood Charitable Foundation joined forces to set in motion an ambitious new initiative for contemporary artists. There were almost no restrictions as to what an artist could propose to the Jerwood/Artangel Open. Indeed, the scheme was expressly set up so that artists could share with us ideas of ambition, scale and complexity that needed significant resources and a specific site or situation for their ultimate realisation.

The commitment of the Jerwood was the catalyst for further generous support for the Open from the National Lottery through Arts Council England, and we are grateful for the advice and advocacy of Sarah Wason and Julie Lomax at the Arts Council's London office. Artangel has enjoyed a long and productive partnership with Channel 4 over the past decade, and we were delighted that Kevin Lygo and Jan Younghusband readily embraced the idea of the Open.

Roger Hiorns's proposal to transform the interior of a council flat was one of almost a thousand ideas volunteered to the Open by artists throughout Britain, and it immediately shone out for its crystalline clarity. Moving the idea from a short précis to a self-generating sculpture has needed a special team to work through a wide range of challenges. Over the past year, we have consulted widely with urbanists, structural engineers, chemists and crystallographers, including Roger Davey and Richard Dowling of Manchester University, Paul Lickiss, Erich Muller, Milo Shaffer and Tom Welton of Imperial College, London, Chris Wise of Expedition Engineering and Stuart Haynes, whom we thank for their thoughtful responses to some unusual enquiries.

Every aspect of the project, from initial research through to the final mix has been led by Artangel's Head of Production Rob Bowman, supported by Trainee Producer James Smith. Their combined contribution to the project – from scouting social housing sites in London to tracking down copper sulphate suppliers in Italy – has been immeasurable. When the focus of the production shifted

on-site in South London, we were fortunate to be joined by Production Manager Broa Sams. They have together worked their way through the successive challenges of the project with an exceptional attention to detail. We have also benefited greatly from the advice of Tim Lucas and Kevin Williams at Price + Myers, the expertise of Barry Goillau and Tom Carter at Benson Sedgwick, and the sympathetic support of Tommaso Corvi-Mora.

As soon as we came across the low-rise block of social housing on Harper Road, we had a strong sense that its scale, history and architecture made it right for Hiorns's chemical intervention. We were fortunate to secure from Southwark Council permission to work at Harper Road over an extended period, and are very grateful to Anya Whitehead, Arts Officer at Southwark, and Jon Abbott, Ron Elston, David Johnson and Maurice Soden in the Southwark Regeneration team for their support. Berni McEwan and Andy Bates at the Leathermarket Joint Management Board and Debbie Walsh, Jean-Paul Maytum and their colleagues on the Lawson Tenants and Residents' Association gave the project their blessing and ensured that the only constraints in realising *Seizure* over the past few months have been those inherent in the complexity of the production.

Roger Hiorns's intensive involvement at every stage of the process, and that of his partner Anastasia Marsh both behind the scenes and during on-site production, has made this an enjoyable and stimulating collaboration. He has discussed his ideas generously and put his energies whole-heartedly into the project. We thank him for sharing his conception of *Seizure* and working so closely with us to make sure that the crystals could work their malign magic.

James Lingwood / Michael Morris, Co-Directors, Artangel
Roanne Dods, Director, Jerwood Charitable Foundation

FISSURES
BRIAN DILLON

'There's no order outside the order of the material.'
Robert Smithson, 'Fragments of a Conversation' (1969)

On a first visit in August 2008, some weeks before the work is left to its own occulted and alchemical devices, the site of Roger Hiorns's *Seizure* looks already as though it encloses a secret of sorts. A modest cloister of late-Modernist design, the flat complex on Harper Road is half-hidden behind a bruise-purple hoarding, its upper storey flaking as if unused to the sunlight, the whole rising to no more than tree height among buildings of more ambitious upward thrust and implacable, unreadable aspect. The block of flats directly across the road has its entrances turned away from the traffic; scaffolding fronts the hundred or so dwellings that loom over the site on the other side. It seems decidedly interstitial: a human-scale development insinuated, almost as an afterthought, among the starker experiments in social housing. The complex turns in upon itself, sheltering its (now departed) community against the chaos of the city.

It is not only because of its late abandonment, or the knowledge of its forthcoming demolition, that once seen from inside the fence the structure seems to open up, to disarticulate into its skeletal components of concrete, glass and steel. Rather, one has the sense immediately of a place in process, not so much derelict (despite the boarded doors and windows, the plaques of rust and spalled concrete) as half-built and heading towards an as yet uncertain future. A kind of reverse archaeology is under way. Over on the left, at the busiest point, certain strata of the building have been stripped away and already replaced with alien materials, such as the metal mesh that will support the crystals. The interior is being mined for a secret that does not yet exist.

The building at 151–189 Harper Road recalls an anxious and conflicted moment in the history of social housing in Britain, and points more precisely to a sudden loss of faith in Modernism. Built in the

wake of the great Brutalist housing projects of the 1960s, it evinces a turn to smaller scales and less audacious visions of the future of urban community. By the end of the 1960s, even architects such as Alison and Peter Smithson, pioneers in Britain of the Le Corbusier-inspired residential megastructure, had begun to design for a low-rise (but still high-density) conception of city dwelling. There is nothing monumental, still less 'iconic', about Harper Road. It seems, to put it too crudely, essentially English in its scale and its subtle nostalgia for a pre-war, even provincial, sort of Modernism; certain rounded corners remind one of the pallid seaside structures of the 1930s. It exists at the periphery of an architectural culture already unsure of its relation to Corbusian rationalism.

In this sense, Harper Road is the ideal site for Hiorns's intervention: a structure whose place in architectural and urban history is tenuous, even negligible, thus tangential to the simple opposition of materials and forms that the gesture of the work might at first suggest. By contrast, the location the artist first canvassed for crystallisation – part of the Smithsons' Robin Hood Gardens in Poplar, East London, a building recently denied listing by English Heritage – might well have bruited too loudly the juxtaposition of crystal and concrete, the decay of a 'failed' building and the sci-fi strangeness of the invading substance. And yet, *Seizure* (with all the violent connotations of that title) cannot but call to mind the fate of the more monstrous avatars of Harper Road: buildings now widely deprecated and in danger of demolition. Among the work's effects is to conjure a dreamscape of British Brutalism cracked and faulted, a once-gleaming future reduced to a grey vista of mineral rubble.

*

The physical process that is both part of *Seizure* and of its pre-history also risks a kind of destruction: the violence of a very visible failure, the possibility that nothing will happen beyond the slow settling of an inert sludge. This danger is of course part of the work itself. The equipment arrayed in advance of the chemical inundation of the flat at Harper Road – a complication of tanks, pipes, funnels and other conduits for mixing and transporting the copper sulphate solution – surrounds what is essentially a black box: the empty and unknowable centre of activity in which the work is 'made'. Here, in the dark, the work composes itself. The artist, having painstakingly contrived the moment of truth (if we can risk a phrase that conjures the magician or charlatan), retreats and allows the 'autogenic' action to unfold.

At this point, a number of time-lines converge, clash and diverge again in unpredictable directions. The artist's labour, physical and psychological, comes to an abrupt halt while he is left to imagine the slow growth of the object; the history of the building and its type is weirdly compacted to a single, occluded, point in space; the chemical reaction itself begins (or so one hopes) and something unprecedented and only partly planned occurs. There is a kind of shuttling here, in advance of the revelation of the interior, between the immediate future and a reminder of deep geological time. The flat complex becomes a time machine, driven by a hidden crystal energy. At the same time, precisely at the moment the space is sealed, it begins to leak metaphors and meanings that the artist, immured in the process, had perhaps hoped to seal away out of sight.

Seizure flirts with certain venerable narratives about crystals, architecture, space and time. Of the scientific and aesthetic stories that attached to crystals in the nineteenth century, none is more sharply defined in the Victorian imagination than the idea of an enclosed and crystalline world – an inviolate universe that, paradoxically, turns out also to be a portal to other worlds and other times. In general, the novels of Jules Verne, for example, describe eccentric versions of the bourgeois interior set adrift in time and space: plush enclosures that can travel beneath the oceans, through the air or even to the moon, allowing their passengers to encounter the vast unknown without ever straying too far from their air-locked floating libraries.

The exception is *A Journey to the Centre of the Earth* (1864). Here the travellers descend into an interior appointed in kitsch splendour – we might say that the planet itself becomes a spacecraft or a time machine. Verne describes the sight that greets his protagonists as they explore the depths of an Icelandic volcano:

> *That which formed steps under our feet became stalactites overhead. The lava, which was porous in many places, had formed a surface covered with small rounded blisters; crystals of opaque quartz, set with limpid tears of glass, and hanging like clustered chandeliers from the vaulted roof, seemed as it were to kindle and form a sudden illumination as we passed on our way. It seemed as if the genii of the depths were lighting up their palace to receive their terrestrial guests.*

What the guests uncover, before emerging again in southern Italy, is a fanciful world of living fossils: ancient mammals and even dinosaurs. But the substance of the planet itself, more plausibly,

contains its own crystalline archive – the earth, it seems, is made of compacted time.

According to the elaborate account ventured by John Ruskin in *The Ethics of the Dust* (1866), the earth also conceals in the form of crystals certain hardened allegories of the moral life. In a series of playful (not to say bizarre) dialogues with a group of schoolgirls, Ruskin outlines his crystalline ethics:

> ... *their goodness consisted chiefly in purity of substance, and perfectness of form: but those are rather the* EFFECTS *of their goodness, than the goodness itself. The inherent virtues of the crystals, resulting in these outer conditions, might really seem to be best described in the words we should use respecting living creatures – 'force of heart' and 'steadiness of purpose'. There seem to be in some crystals, from the beginning, an unconquerable purity of vital power, and strength of crystal spirit. Whatever dead substance, unacceptant of this energy, comes in their way, is either rejected, or forced to take some beautiful subordinate form; the purity of the crystal remains unsullied, and every atom of it bright with coherent energy.*

The mature crystal, on this reading, is obdurate, inviolable, self-identical – even its secondary growths or ramifications are merely decorative adjuncts to the achieved core.

But the crystal is also – and here we get closer again to the logic of Hiorns's process – an image of expansion, growth and transformation: it ceaselessly replicates itself and encrusts any surface that it touches. This sense of the crystal as at once efflorescent and ruinous is at work in a number of texts (and artworks) by Robert Smithson: notably his essay 'The Crystal Land', published in *Harper's Bazaar* in 1966. Exploring the ex-urban wastelands of his native New Jersey, Smithson comments: 'the entire landscape has a mineral presence. From the shiny chrome diners to glass windows of shopping centres, a sense of the crystalline prevails.' In the company of Donald Judd, his wife Julie and Smithson's wife Nancy Holt, he descends into Great Notch Quarry:

> *Cracked, broken, shattered; the walls threatened to come crashing down. Fragmentation, corrosion, decomposition, disintegration, rock creep debris, slides, mud flow, avalanche were everywhere in evidence. The grey sky seemed to swallow up the heaps around us. Fractures and faults spilled forth sediment, crushed conglomerates, eroded debris and sandstone. It was an arid region, bleached and dry. An infinity of surfaces spread in every direction. A chaos of cracks surrounded us.*

Smithson's crystal land is essentially a ruin, but a ruin that points as much to the dissolution of the future as to the persistence of the past. The crystal no longer stands for the future perfectibility of the soul or of society, but is evidence and allegory for the shivering apart of all such utopian visions. The desiccated earth is inseparable from the crystalline products of contemporary technology, the New Jersey shop-fronts are wavering mirages over mounds of rubble. Smithson describes this dialectical landscape precisely in terms of the fate of the architecture of the late 1960s. In his 1967 *Artforum* essay 'A Tour of the Monuments of Passaic, New Jersey', he had already written of a 'zero panorama' that 'seemed to contain *ruins in reverse*',

> *that is – all the new construction that would eventually be built. This is the opposite of the 'romantic ruin' because the buildings don't fall into ruin after they are built but rather rise into ruin before they are built. This anti-romantic mise-en-scène suggests the discredited idea of time and many other 'out of date' things. But the suburbs exist without a rational past and without the 'big events' of history. Oh, maybe there are a few statues, a legend, and a couple of curios, but no past – just what passes for a future. A Utopia minus a bottom, a place where the machines are idle, and the sun has turned to glass.*

Between Ruskin's conception of the crystal as moral touchstone and Smithson's of a crystalline ruin, Modernism dreams of a crystal architecture. Joseph Paxton's Crystal Palace provides the model: a building in which, claims the catalogue of the Great Exhibition of 1851, the very air itself is visible as a bluish haze. (The Crystal Palace, in this sense, is merely an extension of the Victorian obsession with glassed-in atmospheres and ecosystems: greenhouses, aquariums, museum cabinets containing violent tableaux from nature.) This fantasy of total enclosure, of the building as a transparent, impermeable envelope, was extended by Sergei Eisenstein, who planned to make a film entirely set in a vast glass house of his own design, and brought to its absurd conclusion by Yves Klein in his project for an 'air architecture'. It would be finally possible, thought Klein, to dispense with the substance of architecture entirely, and roof our dwellings with jets of air and water or wall ourselves away behind sheets of fire. Architecture would become force rather than form. We would live within a nexus of pure energy, our eyes continually open to the sky and the blue of distance.

It is too tempting to fuse Hiorns's blue crystals historically to the blue of Klein's monochromes. Klein's is ultimately an art and thought of transcendence; Hiorns professes himself allergic to such ambitions,

even as his works seem to promise a sacred or enchanted relation to the object. *Seizure*, he says, is not about beauty; nor does it court the sort of symbolism with which his chosen material, the blue crystal, seems to be saturated. Hiorns's immersion in the process, his trusting to the material, his absenting himself from the scene of the work's production: all of this suggests instead an artist who is more interested in the subtraction of significance – 'the desire fundamentally is not to be stricken with meaning'. The ravishing result of the chemical reaction is merely one more stage in the construction of a specific state of mind: a rigorously organised disavowal of authorial control.

At the same time, *Seizure* is surely so freighted with significance and so drenched with beauty that it sinks knowingly into an awed Romanticism or kitsch: it's impossible not to think, say, of the artificial, crystal-lined grotto that Ludwig II of Bavaria built for his own delectation at Schloss Linderhof, or the hermetic and glowing interior décor commissioned by the dandy Des Esseintes in J.K. Huysmans's novel *À Rebours* (1884). We might recall too the crystallised model cathedral of Hiorns's *Before the Rain* (2003) and his recollection that as a choirboy at Birmingham cathedral he had the sense of the whole building growing, with extraordinary slowness and tedium, outwards from its altar. Hiorns's elaboration of the cathedral's expanding unity has something of the logic of kitsch, which resides in the excessive overlaying or laminating of an object with its own aesthetic significance, as though the structure were trying too hard to impress upon us its status as art or architecture. This false unity between the material and the meaning of the object is constantly suggested by *Seizure* and at the same time denied.

Five minutes' walk from Harper Road, at the centre of the north roundabout at Elephant and Castle, sits the *Michael Faraday Memorial*, designed by the Brutalist architect Rodney Gordon in 1959 and completed in 1961. The stainless steel box – Gordon's original design had called for a transparent glass structure, vetoed for fear of vandalism – conceals a London Underground electrical transformer for the Northern Line. Stranded in an area soon to be extensively redeveloped, the metal facets of the memorial seem to condense the architectural energy of the area and reflect it back along newly fractured lines. The object remains enigmatic and detached from its immediate locale, however: its anonymity (and Londoners' apparent ignorance of what it signifies) is the most famous thing about it.

Seizure is in a sense the opposite of the *Michael Faraday Memorial*. With Hiorns's intervention at Harper Road, all the actual and metaphorical machinery is on the outside, the mystery (and also a

certain banality) on the inside. Or at least, this is the situation that obtains when the space is sealed, the solution allowed to cool and the crystals encouraged to shudder into being and probe the darkness. Once drained and opened, the space confounds expectations that it will seem reclusive, self-involved, aesthetically detached from its surroundings. Rather, the facets, fissures and unexpected, almost vegetal, protuberances of the crystal surface appear to expose the space to its outside; the crystalline perplex becomes part of the architecture of the flat complex and its environs, causing the planes and surfaces of concrete and brick to flex and fracture and rearrange themselves into novel attitudes and estranging patterns. The secret of *Seizure*, if there is a secret, is out.

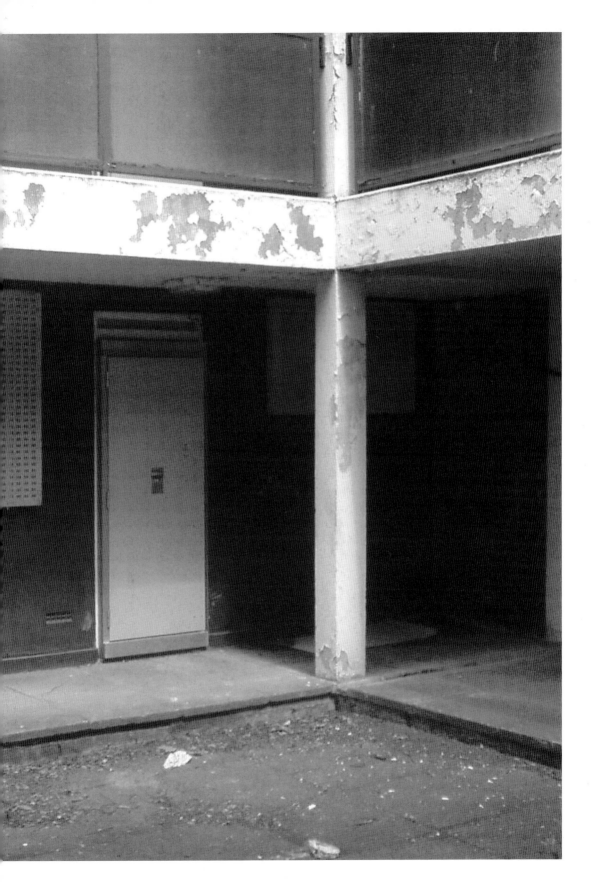

SIGNS OF LIFE
JJ CHARLESWORTH

There has been work going on. Standing on the access balcony of the small block of habitation units on Harper Road, one can look across the grass and the tarmac path towards the large habitation unit called Symington House. Symington House is a tower block, and it is under scaffold. It was completed in 1958, and now, in 2008, it is undergoing renovation. The scaffolding structure partly obscures the façade of the building, its white-painted concrete and windows obstructed by the scaffold's spindly greyish lines and wooden decking, installed at each floor level. But a clear view of the building is hindered by the sheets of blue plastic netting hung from level to level to prevent debris falling to the ground. This blue sheeting hangs like a veil, a screen of cold colour that turns the light-welcoming windows of Symington House into dark, blank squares, dimly glinting, impenetrable.

There is no work going on now. The access decks of the scaffold are not empty, however. There are objects on these decks, but these are not the tools or equipment that would be used for the business of renovation. These are domestic objects; a child's bicycle, a bedside chest of drawers, an ironing board, some exercise equipment. They punctuate the decks at irregular intervals, in little clusters outside one or other of the apartments in the block. They are moments of surplus activity, excesses emanating from the body of the building, currently wrapped in its lattice of grey scaffold and its skin of perforated blue plastic...

This view of Symington House can be seen from the derelict low-rise housing block, at 151-189 Harper Road, which contains Roger Hiorns's project *Seizure*. This block, Symington House and the complex of council housing further north – the Lawson Estate – were built by London County Council in the 1950s and early 60s. A half-century later, while Symington House undergoes renovation, 151–189 Harper Road is scheduled for demolition. A set of spaces once designed for human habitation is now empty; built in the heyday of the Modernist movement, these spaces faintly echo Le Corbusier's declaration that

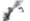

'a house is a machine for living in'. Yet as the Harper Road block sits abandoned, after five decades of being lived in, the echo becomes a question: what kind of life can be lived in this place?

Seizure, like many of Hiorns's previous sculptural works, uses the chemical process of crystal formation. Hiorns has regularly used the fast-growing blue crystals that are formed in copper sulphate solution to coat the surface of an object. The objects that have been subject to this process are sometimes organic and natural – as with the desiccated thistles that adorn *Discipline* (2002) – or they are machine-like and industrial, as in the various motor engines of *The Birth of the Architect* (2003), or *All-Night Chemist* (2004). But another recurring object has been the architectural form of the cathedral. Model cathedrals incrusted in blue crystals appear in *The Birth of the Architect* and other recent works, but go back to one of Hiorns's earliest works, *Copper sulphate Chartres, copper sulphate Notre-Dame*, made in 1996.

Throughout these works, we are presented with works of human architecture and technology overgrown and overwhelmed by the growth of blue crystals. Hiorns's use of a model of an object in his sculptures is an exception limited to the cathedrals, which offer themselves as fictions or fantasies of an idea yet to be realised; that of a real architecture overgrown and overwhelmed by the growth of these crystals. It is this idea that is now realised with *Seizure*. And with this shift from the scale of the model to the scale of architecture, and the shift from the imaginary to the real, the growth of blue crystals takes on a troubling new meaning, which questions the very significance of human life and human history, at a time when what it means to be human, and the direction of human society itself seems less certain than ever before.

With *Seizure*, Hiorns expands on a central theme of his work, that of the thing that makes itself, an object that *self-produces* rather than is produced by the agency of the artist. Along with the various crystallised objects, Hiorns has previously made sculptures that produce columns of fine soap bubbles, seemingly endlessly and out of nothing. In parallel to these strictly chemical or physical processes, Hiorns has also made works that suggest various forms of biological production, often turning on metaphors of sexual and asexual reproduction as well as excretion. Birth is explicit in the *The Birth of the Architect*, with its cathedral connected through umbilical cables to a car engine, for example. In some recent projects Hiorns has used semen to coat super-bright light bulbs and light-sources. In various steel sculptures such as *L'heure bleue* and *Vauxhall* (both 2003),

perfume is sprayed on the narrow standing steel panels, at about mid-height, suggesting a pissed-on stain, and in *Untitled* (2006), two old window-frames, encased in perspex, are smeared with what is purported to be excrement.

What is common in all of these works is the attention to forms of human biological production, as much as non-human, physical and chemical processes. Birth, excretion, urination and ejaculation are the various physical substances which indicate those processes that contribute to the reproduction of human life. In Hiorns's work, however, these occur in ambiguous combination with technology and architecture; while emanating from what we know to be human, these substances take on an identity partly independent of their origin. Rather than operating as indexes of human presence, they become material symbols of the process of production and reproduction, separated from the original reference point. This is perhaps why these substances take on the character of something either sacred or alchemical, but in either case something occult, whose properties go beyond the norms of raw matter.

What binds these distinct aspects of Hiorns's work is a preoccupation with the nature of the human and the inhuman, and how we distinguish between them as the different kinds of process that matter can undergo. The form of the crystal and the process of crystallisation are exemplary in this respect – it is about as far from the human as matter can be. Entirely lifeless, based on nothing but the dynamics of inorganic chemistry, the crystal nevertheless is said to 'grow'. It invades and coats a surface with absolute indifference, like mould, or rust. And yet, unlike either of these – organic or inorganic processes – it is not necessarily an inherently *entropic* process. While a mould might exploit the decay of the dead tree that it grows on, or while rust signifies the alteration of iron as it is exposed to air and water in a process of oxidisation, the process of crystallisation is one of *resolution*; it is what happens when the internal chemical instability of the copper sulphate solution resolves itself through the formation of the crystal. Perhaps it is also significant that in the process of crystallisation, transformation is achieved through an internal process rather than external application. In a biological process such as the growth of a mould, the transformation of one sort of matter into another requires some external input of energy or outside substance. Similarly, with an inorganic process such as rusting, the process occurs only through a combination of external elements – the presence of oxygen and water. By contrast, crystallisation is an ordering of molecules within the crystal solution itself.

Crystallisation, then, is the purest expression of a self-contained, self-producing process of matter which goes from internal instability to stability, indifferent to materials and energies outside of it. In the iconography of Hiorns's work, it is the clearest expression of the auto-generative theme that runs throughout. In the context of Harper Road, and of the crystallisation which has overcome an entire space of habitation, it is also the most absolute contrast to the processes of life and of living that this space bears witness to. But what does the contrast tell us about the space that the crystals have taken over?

In his 1923 book of essays *Toward an Architecture*, Le Corbusier writes:

> *You employ stone, wood, and concrete, and with these materials you build houses and palaces: that is construction. Ingenuity is at work. But suddenly you touch my heart, you do me good. I am happy and I say: 'This is beautiful.' That is Architecture. Art enters in...*

It is difficult to imagine whether the little flats on Harper Road did their residents good, or made them happy; harder still to think that art had a part to play in the creation of these austere, reduced, limited spaces; a bedroom which doubles up as a living room, a tiny bathroom and a small kitchen. Le Corbusier's dictum that a house should be understood as 'a machine for living in' had, by the end of the twentieth century, become a degraded parody of itself. Where rationality and utility should have been watchwords for human progress and happiness, they instead became the justification for merely machine-like living. Harper Road, Symington House and the Lawson Estate, like countless other council housing developments across London, were built to replace London's bombed-out and decrepit slums in the austere years of the immediate post-war. Yet while the urgency of re-housing ordinary people in decent accommodation no doubt influences the basic and limited design of much of these developments, there is nevertheless something mean-spirited and ungenerous about these little spaces, that runs counter to the early optimism of the Modernist architectural movement. No wonder that today, much of the Modernist period of urban planning and architecture is denounced for its inhuman character and dehumanising effects. The cell-like quality of bad Modernist housing projects has been much-criticised since then. If this house is a 'machine for living in', then the lives that could be lived in such a place must necessarily have been diminished by it.

It's easy today to complain about the false promise of Modernism. Today these buildings stand as monuments not to an ideal of human

emancipation, but rather to a dystopic view of megalomaniac town planners and the dictatorial fantasy that human beings could be remodelled by reshaping the spaces they lived in. Some of these buildings are preserved, some are demolished. But it is of little importance if some survive, because the ideal of the Modernist era – the vision of humanity expanded and enabled by the advent of the 'machine age' – has largely vanished. We look back to the clean lines and utopian designs of the Modernist period quizzically, as if it were out of sync with our own present; and yet, ironically, contemporary society continues to build its living spaces in similar stacks of standardised little boxes.

Our cultural attitude to the passing of the utopian ideals of twentieth-century Modernism seems to touch on *Seizure* only indirectly. But between the crystallised flat of 159 Harper Road, its empty neighbours and the slowly renovating, still inhabited block of Symington House, one might attempt to make a set of connections that speak of the place of human life in the structures it builds for itself, of the human energy that the act of building itself represents, of the process of time passing, and our sense of history and the present.

Looking back at Symington House under its skin of scaffold and perforated screening, one notices again the accumulation of domestic things put outside of the flats onto the temporary wooden decks. It is as if the inhabitants have expelled objects they don't need in their immediate day-to-day, onto this handy extra bit of space that has become temporarily available. It seems unremarkable, but it is the creative, ad hoc response of people faced with not enough space for living. Confined to the rigid little boxes of their apartments, people are colonising spaces that have become temporarily available. It is a sort of growth on the building, a human activity which exceeds the building's limitations.

While the vast Modernist house-building projects of the 1950s and 60s may be out of favour, it still marked a great reconstruction and expansion of human living-space. Today, the number of houses built each year has fallen to its lowest level since the war, and we do not build enough to replace what we have, or what would be necessary for future growth.

But how do such realities connect to this strange environment that Hiorns has made happen, in this abandoned apartment in South London? The dense, dark cobalt blue of *Seizure*, its implacable and complete smothering of the straight lines of the original flat, seems to express a blank indifference to the troubles that afflict human building and human dwelling. If *Seizure* had continued its growth, one might

imagine how the angles of the space would progressively disappear, as the crystals continued to grow inwards, towards each other. In-growing, like a crystal geode, this former space of human habitation – with its worn lino and peeling paint, with all the marks left by a living person – would be filled up, would disappear, transformed into pure crystal growth, with all signs of former human life obliterated. And with its cave-like floor, undulating with compacted crystals, *Seizure* suggests a return of the geological and inorganic world of pre-history. Rather than the complex and unstable relationship between human beings and their own built world, *Seizure* offers a lifeless form which, with its poisonous and lacerating surfaces, cannot even offer the primitive human shelter of a cave.

Auto-generative, inward-looking and in-growing, independent of human intervention and human touch, *Seizure* continues Hiorns's fascination with the metaphorical potential of the inorganic, and of the strange life of inhuman processes. 'Seizure' might indicate the recovery of something that is rightfully owned, or a moment of paralysis or sudden arrest in the processes of a living organism. Here, in this flat that has become not a cave but a crystal geode, it is as if the living space of modern humanity is being reclaimed by the inorganic. While a more conventionally romantic ecological narrative might imagine the reclamation of human space by organic nature – ruins overgrown by plants and trees – *Seizure* expels even organic nature in favour of the inorganic, choosing simple molecular growth over that more complex and curious molecule, DNA.

Seizure's perversely inhuman spectacle doesn't present us with the scene of a modern world, derelict or abandoned, or a futuristic fantasy of the ruins of a bygone civilisation. Instead it negates this human world and its human-scaled architecture, filling interior space with hard, inert matter, reclaiming it from those who have given it up. *Seizure*'s paradoxical existence lies in the fact that, like any crystal geode, it has to be cut open to reveal its internal order and complexity, its hidden opulence and dazzling colour. In other words, the very act of seeing its internal form assumes a human presence; yet in this scenario, it is the human witness to the crystalised space which has become alien. No longer a derelict space of modern human habitation, *Seizure* positions the human spectator itself as a trespasser. *Seizure*'s internal order is a physical phenomenon before it is a visual one – by entering it one brings to it one's own human sense of visual, aesthetic value as if it were an intruder. However much we think of it as an artistic spectacle, *Seizure* remains indifferent. All it does is grow, in darkness.

Alien and strange though it seems from the usual shape of everyday existence, *Seizure* nevertheless mirrors a broader anxiety in contemporary society. If the Modernist political and aesthetic visions of the twentieth century anticipated human liberation through technological and productive expansion, and the indefinite growth of human society in both quality and quantity, at the beginning of the twenty-first century, that ideal of growth and expansion is profoundly undermined and called into question. In all aspects of life, the virtues of human growth and social expansion are challenged and rejected. Apparently, there are too many of us, producing too much and consuming too much, and spreading too far. Tall buildings are celebrated not for their reach and ambition, but tolerated because they keep us from spreading. In terms of the built environment, of course, such paranoia about human expansion exerts a powerful and real restraint on change and development. Inertia and entropy are characteristic of the experience of urban space in Britain. If little is built, things are equally slow to be destroyed; the block on Harper Road has been slated for demolition since 2005.

Inertia, doubt and restraint are the defining themes of contemporary Western culture, in stark contrast to the optimistic and expansive visions of the previous century. These are partly driven by the political exhaustion that followed the end of the cold war and the putative end of 'grand narratives'. But today, we seem ever more uncertain about our right to exist on the planet, given that our explicitly modern presence appears to be the source of all the planet's troubles. Such strongly misanthropic and alienated perspectives, which envision a world where humanity itself is the problem, are not hospitable to the expansive, human-centred optimism that underpinned the modernity of the last century. In this poisonously down-beat cultural atmosphere, it is not hard to grasp how *Seizure* resonates, even as it remains indifferent. *Seizure*'s entropic, mineral and inhospitable formation, independent of human will, echoes all our worst moments of doubt about what a world without humans would mean. The machine for living in has stopped. There are no signs of life. Art enters in.

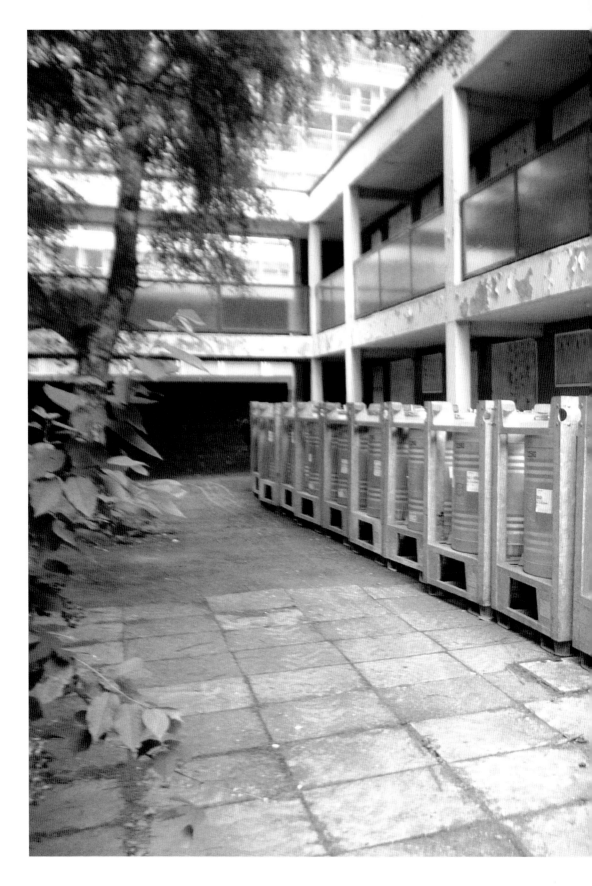

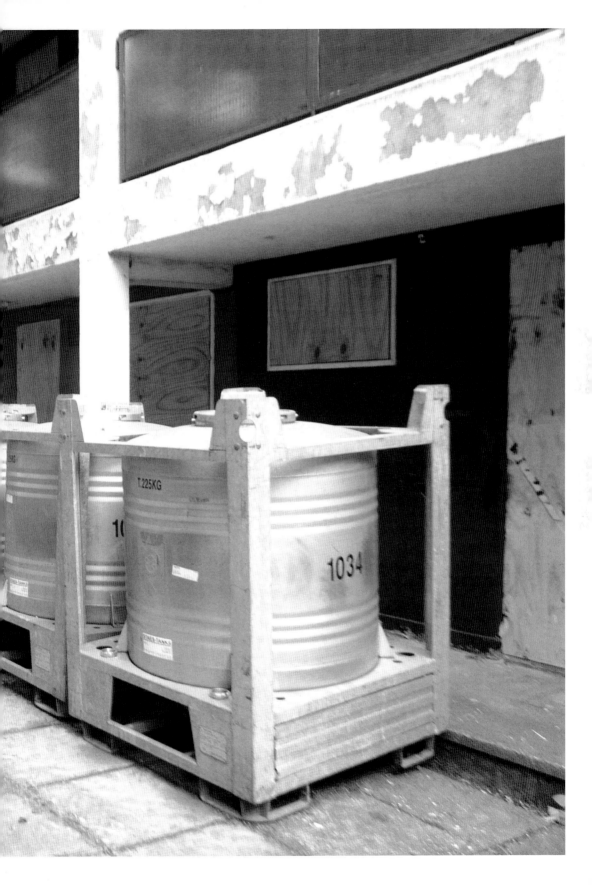

CRYSTAL HABITS
TOM MORTON

This is a place where lives were lived. Anonymous lives, certainly (we can only guess at what tears and exaltations they knew), but lives nevertheless, with their details and trajectories, their hopeless deals with time and change. No longer. No more and never again. These lives have been decanted, and their container scheduled for destruction. Before that, though, it will swill with one last draught. Not of life, or its parody, but something parallel to it. A growth. A mineral protocol. A willed obsolescence.

Roger Hiorns's *Seizure* is the result of the introduction of a very large volume of liquid copper sulphate solution into a very small place. 151–189 Harper Road is a building made up of bedsits, and the idea of single occupancy, of a monadic, childless existence, is important to the process Hiorns set in motion within its walls. *Seizure* is not a natural born thing, and has had little in the way of post-partum nurture. Rather, it is the product of an agency exercised and then self-absented. More than once, I've wondered if Hiorns does not regard that agency as an impurity of sorts.

Otherwise empty of furniture or fittings, *Seizure*'s antechamber has a mirrored cabinet fixed to its wall, a remnant of its time as a domestic dwelling. It's a humble thing, this cabinet, but its reflective surface serves to show us a familiar face, a set of familiar wants and needs. We get to thinking of the people who once lived here and the times they too peered into the mirror's depths, surprised in their solitude, perhaps, to be reminded of their own particularity. In this airlock, an exhibition of sympathy (with yourself, with imagined others not so very different from you) is played out that seems impossible in the space beyond. Cross the threshold into *Seizure* and a transformation takes place. There, we become an alien species. There, we become soft, yielding intruders into a hard and brittle world.

To enter Hiorns's work is to feel yourself soaked in intoxicating colour. The artist's introduction of the copper sulphate solution has caused blue crystals to bloom from the bedsit's every surface,

jagged flowers without pollen, stamen or roots. They cover the walls and the light fittings, the ceiling and the bathtub, and crunch into a frosty slurry beneath the visitor's gum-booted feet. Light refracts from their planar surfaces, not quite glistening (its tone isn't warm enough for that), but glittering with the surety of geological fact. There is a beauty here, but one that, unlike the Darwinian props of a peacock's plume or a plump, bowed lip, is utterly unconcerned with the imperfect business of the biological reproduction of the self. These crystals are not merely sterile, they are determinedly inorganic – their blue is the blue of the liquid used to stand in for faeces or menses in advertisements for nappies or sanitary napkins, or of a mouthwash designed to rid teeth of precipitating, furry plaque. Formed from their own amniotic fluid, they have undergone no mitosis, no splitting from some central, zygotic point. Rather, they have come simultaneously into being, urged by what mineralogists term their 'crystal habit', which is to say the specific conditions – heat, pressure, space, trace impurities, the grinding of their lattices one against the other – of their growth. 'Habit', in this context, is a telling term, suggesting as it does a compulsion, a loosening of control, an incomplete mastery of mind. These cerulean shards have not been shaped and sharpened by a commanding consciousness, they have merely happened. An autogenesis has given rise to an auto-aesthetic, a radical indifference. The title *Seizure* evokes both the act of capturing an object, space or idea, and a neurological event in which excessive electrical neuronal activity prompts a series of convulsions, commonly followed by memory loss. Having colonized the apartment, Hiorns's crystals will, left uninterrupted, eventually destroy its very fabric, erasing every trace of the architectural and personal histories it embodies. We might imagine them as pathogens, or malign tumours, but those are human categories, and human categories are unimportant, here. These blue growths do not – and cannot – know what they have displaced or consumed. Their existence is one of perfect purposelessness, inexorably carried out.

As an architectural environment, *Seizure* calls to mind both the Neanderthal's cave and the artificial grottos of the Renaissance, a primordial dwelling and a place where contemporaneous stylistic norms were suspended, and a perfidious excess of decoration could take root. (It is worth remembering that the word 'grotto' is related to the Italian 'grotta', or crypt, and also to 'grottesche', or grotesque.) The cave, of course, speaks of bare life, and perhaps this is why that supreme anti-materialist Plato, in his *Republic* (360 BC), has Socrates present it as a location in which we are subjected to an illusory vision

of reality, and somewhere from which we must escape in order to attain a knowledge of the true nature of things beyond their representation, and eventually beyond their specific physical being. For him, it is the Ur-spot of unreason, and we might say the same of Hiorns's crystal-crusted chamber, at least in so far as its chaotic contours have no author, merely a prime-mover, a distant, non-interventionist demiurge.

And yet, *Seizure* is far from being a place of smoke and mirrors. A creedless form of truth to materials has been rigorously observed here, and while this unusual environment might prompt certain viewers towards spiritual reveries or sci-fi nightmares this is by no means intrinsic to the work. Within this spangled apartment, the plain physics and chemistry of crystallization are mindlessly played out, and anything exterior to that – whether it be a belief in a Christian God or in the Platonic 'form of all forms' – is something we introduce ourselves, like a painting onto a cavern wall, and should be honoured or disdained as such. Hiorns has said that 'the corrupting influence of the viewer [is] the work's deepest compromise', a notion brought to immediate and dramatic life by the splintering of crystals as we step across its floor. It is at this point, perhaps, that the notion of the grotto, and its nexus of etymological relations, is useful. The subversion of 'rational' architectural orthodoxy (respectively Classical and Modernist) through 'irrational' adornment is common to both Renaissance grottos and Hiorns's jewelled council flat, and points to a wider set of concerns about the relationship between formal and mental hygiene, and how these have been employed in the exercise of power. These structures partake of 'the grotesque', a term commonly used by art historians to indicate a stylistic tendency towards perversion or profligacy, but also one that is employed by John Ruskin to wider effect in his *Stones of Venice* (1851–3), where it describes the human inability to comprehend objective reality as anything but a phantasm, a misleading metaphor for itself. The grotto of Harper Road, it would seem, forces us up against this limitation. Stumbling through it with our feet and our minds, we become embroiled in a mutual toxicity, and a mutual violence. Flesh is nicked, and blue shards are stolen as souvenirs. A rapture never materializes, or rings hollow against the chamber walls. In this meeting of curves and edges, subjects and objects, neither the work nor the viewer can survive each other for very long.

Back, for a moment, to the matter of agency. Historically, we are now far from the point when artistic activity was wedded inextricably to facture, but Hiorns's withdrawal from *Seizure* at the early stage of its chemical gestation is not about the dematerialization of the hand, or of the art object, but of the artist himself. We might formulate this as a

delegation of responsibility for form to materials, and while partially true, this does not adequately describe what Hiorns has called his attempt to 'obsolete myself from my own realm of activity'. While the introduction of the copper sulphate solution into the Harper Road building has resulted in a work that, on the level of spectacle, does not disappoint, I suspect that he would have still been satisfied had the process resulted in nothing much more than the slight staining of its walls. This isn't to suggest that *Seizure*, or any of Hiorns's other works that employ unpredictable substances, is a piece of disinterested research, rather that it provides a model for engaging with the world that is at once attractive and disturbing.

As Søren Kierkegaard points out in his *The Concept of Dread* (1844), it is impossible for conscious beings not to act, not to anoint or befoul the places we inhabit, and this is something that causes us no small measure of pain, because to act is to risk failure, or (perhaps worse) misapprehension. *Seizure* stages a situation in which human agency is reduced to pure, bright intention, passing the liability for any consequences onto a substance that, while it may seem to mimic a living thing, knows nothing of the tender sting of being. Like a prayer, then, or the tense sacraments of an obsessive-compulsive – a sequencing of the universe that is not really about understanding, nor comfort, but the recognition of their absence, their lack. If there is a ghost that haunts *Seizure*, it is of a fantasy of a work of art that simply happens, without the intervention of a particular heart or mind. Crystals, though, need their impurities. It is through these that their habits are formed.

To describe a work of contemporary art as ambiguous is commonplace, but few marshal their contradictions with *Seizure*'s urgency, or aplomb. It is a fantasy of innocence and confession of culpability, a lifeless growth that critiques the pathetic fallacy and croons its every dulling, seductive note. Most of all, though, it is a work of art that at once disavows its audience and needs their corrosive presence to become fully itself. As I leave the bedsit, I press my hand against the mirror in the antechamber. My palm obscures its own image. The glass cools my blood. My blood warms the glass.

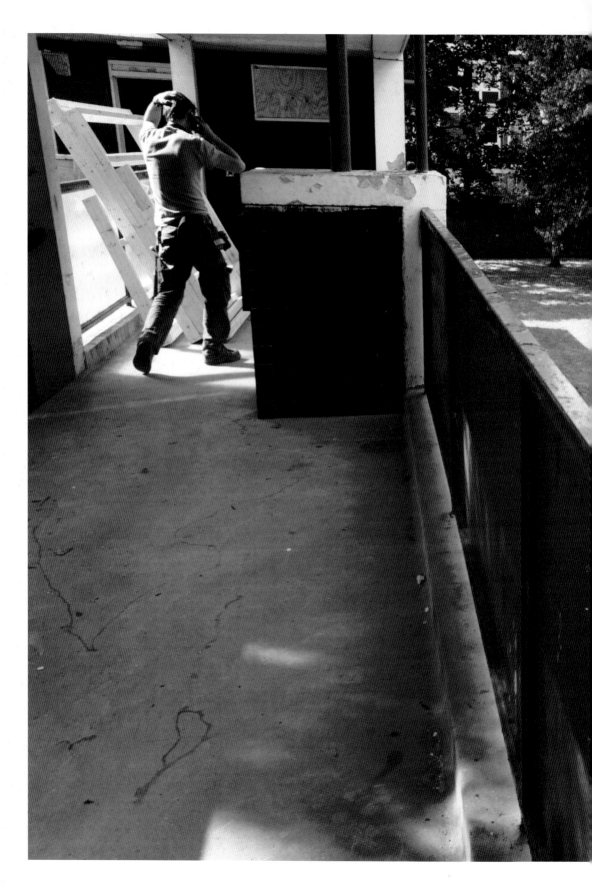

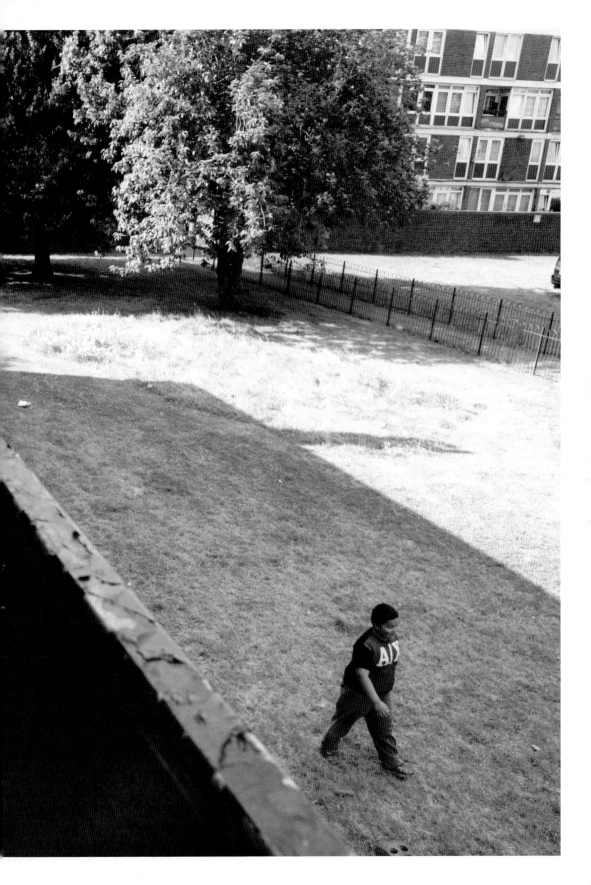

THE IMPREGNATION OF AN OBJECT
ROGER HIORNS IN CONVERSATION
WITH JAMES LINGWOOD

JL *You use a wide range of different materials. What determines
the choice of what material to use?*
RH The way that I approach making certain artworks is to have some
kind of psychological position, a place that is grown from a certain
ambiguity. You always have to think about materials in terms of being
real things – you have to cut them off from what their real use is, to
interfere in their world-ness. You have to start from this material
basis, and understand yourself through the material – it gives you a
version of detachment.

JL *But the materials you use are quite specific and seem to
be precisely chosen – fire, detergent foam, copper sulphate
crystallisation. Is there anything they have in common?*
RH The key issue is whether it's possible to choose a material which
helps in creating an isolation – an isolated object. They were all
carefully chosen, through a kind of evolution, through spending time
with the material.

I'm not somebody who's interested in a deliberate form or design or
style. These materials – fire or foam or crystal growth – have their own
autonomy and their own aesthetic. Each material is an interpretive
tool, which simply takes me out of the equation.

JL *Were there materials which failed to do what you wanted them
to do?*
RH I don't think I ever chose a material just to ask it do something
or to coerce something out of it. I have quite an illustrative way of
working, a very good idea of what something is going to be before
it's finished. I tend to think out the problems beforehand – it's part
of the practice, part of the internal psychological perspective on how
to make artworks. I rarely use drawings or other aids. The work is
an extension of my way of thinking – working things out in my head,
and then working it out as a reality. This becomes a useful way of
selecting materials.

JL *You relinquish control because the materials have their own life, but you have a good idea of what will happen.*

RH There's a set of positions or desires that you want the work to fit within or to have a certain relation to. But these aren't rules or set pieces written down on a piece of paper. It's a judgement about how something will be over a certain time and there's an emotional evolution in the way that they work. These act like filters, internal mental filters, which you pass all of your thoughts through.

JL *There's quite a strong structure underpinning the work?*

RH It's an aesthetic procedure; everything gets channelled through a certain way of working. In a way, there's a ridiculous amount of structure, but it's an internal structure, an ongoing internal monologue. The desire, fundamentally, is not to be stricken with meaning, not to ascribe meaning to everything you do… an outside stimulus will always magnetise the structure through certain different positions.

JL *How did you arrive at the idea of working with crystallisation?*

RH It's a bit like a childhood memory, I can see parts of it more than the whole. A while ago, maybe ten years, I needed a material to achieve a certain kind of detached activity, and on a basic level an act of transformation, a material which was going to simply, rationally transform another material. I felt a system of nature like crystallisation would do.

Vauxhall, 2003,
Steel and fire,
Tate Britain,
London

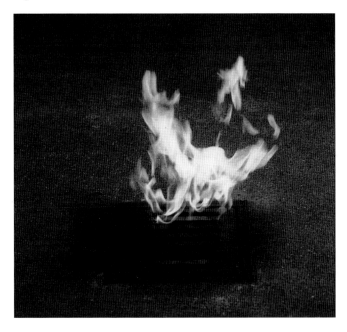

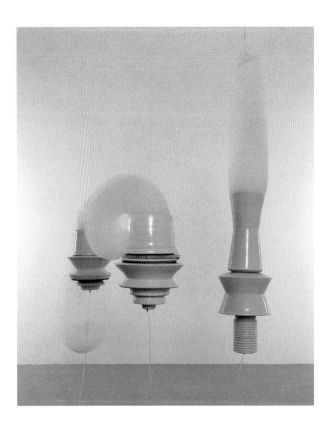

Beachy Head, 2006. Ceramic, foam, compressor, Tate collection London.

JL *What kind of control did you want over this transformation?*
RH I was very interested in the idea that the artwork would exist aesthetically without my hand and in me not being present for most of the making. I would put together some kind of basic structure which would then grow into something else, the unanticipated other.

So working with crystallisation seemed to solve the problem of style, of the position of style being a static moment. Once people accept it, then it tends to stay with you rather than with anyone else, it builds a cave around you.

Sculpture is slow, and object-making is very slow. The object is being made, is made by the reaction that happens over time, these materials are introduced to each other. That was interesting to me, instead of processes like welding, sawing and, importantly, the hammer.

JL *A slow process gives you the chance to stand back?*
RH I am completely objective about my own artwork. I can stand outside of it, against the world, and work out whether it should exist or not. That's why I use materials which enable me to become detached, materials which are their own thing, have their own genetic structure.

Rather like copper sulphate is described as auto-genetic, my work is also auto-genetic, it tries to make some sense of my psychological position.

JL *What led you to the specific material of copper sulphate crystal – was it the blue colour, or the size of crystal that can be grown?*
RH I had an object that I wanted to deal with in a particular kind of way. I was thinking about cathedrals at the time, the structure of cathedrals, and of a material that could have some kind of structural relationship to cathedrals.

I spent a lot of time in a cathedral when I was younger, as a choirboy in Birmingham, subjected to the awful monotony. Anyway, you become embroiled in the architecture, and its central-ness, the focus of attention on the altar. You consider the cathedral is grown from the centre outwards, from an altar outwards, which seems to me how you have a relationship with religion, that you have a central point that everything relates to. I have to add that central-ness is a Birmingham obsession, in its geographical position, its whole identity based on the centre and its constant reinterpretation. This Birmingham cathedral altar seemed as ground-zero to this consideration.

The crystal has a similar form of activity. It starts from the scale of the molecule, it has its specific set form from which it cannot move or deviate, unless of course there is impurity introduced. In the environment of the saturate the crystal grows forever outwards.

JL *It reproduces itself, it has its own system.*
RH It's a different kind of control.

Copper Sulphate Chartres, Copper Sulphate Notre-Dame, 1996. Card, copper sulphate. Courtesy Corvi-Mora, London

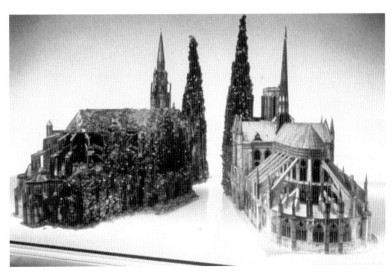

JL *Were you making something which you hoped could overcome a kind of totalising world view through its own systems and structures? What's your relationship to religion now?*

RH I see religion as something we have to grow out of, it's holding us back from the next stage of a mental evolution, and to some degree a scientific evolution.

My desire is to find an aesthetic which would eventually find its way towards a different way of thinking. There's no way of assuming that a way of thinking might exist for the work right now, in the present, so perhaps the works are made for an interpretation that is yet to exist, maybe 20 years in the future, or 100 years perhaps – but it doesn't exist now.

I need to find a way of taking a number of things which are prevalent in culture and try to push them aside. And I try to do it materially. At the moment I am working with objects which I try to affect through the introduction of other objects. Brain matter on engine parts, on industrial filters. These materials are cultural and specific objects, their nature and being are understood in this present period. It's my concern to develop these objects further into the next phase, to de-nature and de-identify them. Through practiced 'aggressions' and misuse. My aesthetic, if it can be called an aesthetic, is a mis-use of common properties.

JL *When you're pushing aside an object, do you want to push aside what they represent? The host object is as important as the material introduced to it, the engine head of a powerful car.*

RH Yes, actually I try to be deliberate and heavy-handed when it comes to the metaphorical side of things. When it comes to crystallising a BMW engine for example, it was the closest I could get to the implausible idea of crystallising a pure expression of power. And then it fails, because as soon as you crystallise something which is so perfect, as the BMW engine is so aggressively perfect, it becomes obsolete.

JL *As JJ Charlesworth has suggested, the new object becomes somehow sacred?*

RH If you focus attention on any object for a good period of time, then it becomes *the* object rather than just any object. That is the main paradox of sculpture somehow. One of my persistent problems is that I have a problem with making objects full stop. I suppose it's a privileged point somehow, because I can be completely objective about whether something should exist or not. That's the advantage of working with materials which are auto-genetic.

JL *It makes the process impersonal?*

RH Yes, it's useful, simply because I don't have a style…

JL *…but the choice of materials can become a style, because these materials can only perform in certain ways, can only achieve certain kinds of form.*

RH Once it becomes too familiar, it is time to move on.

JL *You don't want a personal association with a material like Beuys with fat or felt, or Matthew Barney with vaseline?*

RH They can become a crutch, you have to move away for your own sanity. In truth, the process is an investigation, a constant investigation not a position.

JL *So there's no personal mythology, ostensibly*

RH Ostensibly no. The materials when I start to work with them hold a certain chaos, then you gradually become completely aware of

Untitled, 2007.
Engine, aluminium,
copper sulphate.
Private Collection,
London

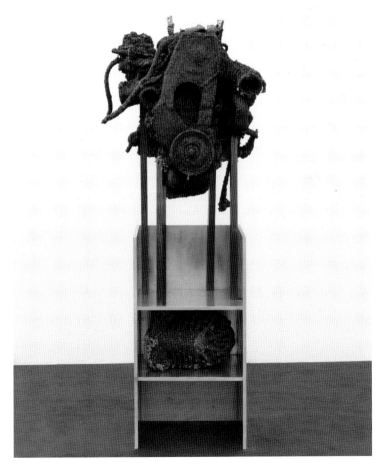

their potential, their properties, and then it doesn't become important any more.

JL *But sometimes a material just seems right?*
RH If you do stay with a material for a long time, then maybe other meanings will come along, especially as the material get pushed into the real world. Maybe with *Seizure*, we are taking it to such a degree that the desire to investigate further what copper sulphate crystallising can do will be over, it will be obsolete.

JL *Were there other kinds of crystal forms which have been possible, or is there something specific about copper sulphate?*
RH There are other possibilities, and I got into trouble finding out about them. I scared myself when I first started to look into crystallisation. Copper sulphate is readily available, but there are also other chemicals too which you can get hold of. I tried another material, potassium dichromate, a bright orange material, which turned out to be really quite poisonous. I was living in a flat in New Cross at the time, and the day that it arrived, I unwrapped it, and thought great colour, and played with it, and tried to make some crystals... then I read the leaflet, which you're supposed to read first, and it turned out that it was incredibly carcinogenic. Great work!

JL *What about its blueness – was that something else which attracted you to the material?*
RH The colour was always a sidetrack for me, it was never about the beauty, about claiming something to be a beautiful object after it had undergone the crystallising process. That would just be banal, though banality is not a bad thing always, but it's meaningless in the wrong way.

JL *Blue has such a particular history, think of the early Renaissance. There's a fascinating book by Paul Hills about painting in early Renaissance Italy, where painters would agree with their patrons as to how much gold and lapis lazuli they should use. It was the colour of the heavens... Then there is Yves Klein and International Klein Blue?*
RH When you're starting out as an artist, I think you have to be pigheaded about your position, maybe even revisionist. You have to claim the world for yourself, and then you try to work backwards and filter out what you don't need and take what's good for you.

JL *There's no tiptoeing around?*
RH No, and misinterpretation can be really useful too. You just take

what you want. I was never really a big fan of Yves Klein, because I think I saw quite a lot of the weaker work first, the objects, and it didn't connect with me.

JL *He also used fire as a material – or at least the residues of fire.*
RH Yes that's true, I was interested in those works, they were architecturally aggressive. For me, a good way of starting is always with some kind of internal aggression. You have to have an impetus, to take something and do something with it. To change things is aggressive.

JL *Aggressive against authority, against what these objects exemplify?*
RH Maybe the process of claiming them is aggressive but I never thought of the objects themselves as aggressive in their finality, just their processing perhaps. Perhaps there's a mimicking of authority, of authoritarian language. This comes out more in my writings. There's an interest in coercion. There has to be if you're interested in transforming the object.

JL *There's no destruction of the father going on here?*
RH No, my father did a pretty good job at doing that to himself. He spent a lot of time in hospitals when I was in my teens… I was in a very ambivalent place when I was growing up, my father had a self-destructive illness, so all of the attention went there. So you watched it, and you don't really understand the problems. I was in a kind of no place, because I didn't know where the authority was. Maybe that's quite useful, perhaps I desire that ambiguity of authority, the lack of place. But the work is not autobiography, I'm very opposed to that.

JL *Can we talk about the genesis of* Seizure?
RH I was just checking in my sketchbooks for 2006. The first thing I wrote in the new year (perhaps childishly) was 'transgressive and vulgar'. I knew that something was coming along and I drafted an initial statement on a piece of paper. If the work takes off – in the imagination with just a few lines, then that is usually enough. It is like a magnification of the psychological state I was in at the time. It's an extreme possibility.

JL *What kind of psychological state?*
RH It is a building of compulsion on compulsion, an enactment of a thought which came at a bad time. So there's a pathology about that – that a thought coming out of a state of depression can end up as a massive problem, a difficult work. I always think of this piece as a

deeply internalised project, a forever growing inwards, an unrelenting, unknowing chemical activity going deeper inwards. It is built around a piece of architecture which has a similar sensibility somehow.

JL *What led you to the kind of architecture? The space we found is quite specific and there is the idea of working in a small part of a larger whole, where the living spaces were replicated, all the same size with the same configurations.*
RH I have a deep interest in Brutalist architecture and the best example of that is the Robin Hood Estate designed by Alison and Peter Smithson in Poplar, East London. That was the place I was initially thinking about.

JL *What was it about the Robin Hood Estate?*
RH These buildings were about containing large groups of people who were all living in the same kinds of places and being encouraged to think the same kinds of thoughts. There was the idea of a collective, the dream of growing together for the better good, and I have always been very distrustful of collective identity, like my attitude to religion perhaps. These kinds of building don't work; as a model they have not passed the test of time. Great symbols of collective will, which were treading on an individualistic attitude in the form of small, pokey flats. They give you very little architecture, the nominal amount of expression you're allowed to have, they were ungenerous in that respect. In the great social experiment these buildings inferred, they provided no room for movement, zero mobility to move further, they are completely static materially and emotionally.

JL *These kinds of buildings began to deteriorate quite quickly.*
RH They're still somehow rather beautiful. They seem to carry the stain of life, to take in everything they were experiencing. I am always interested in considering this material called 'experience' and what would that be. The grinding up of a jet engine is experience. The use of brain matter on industrial filters is experience. The collective nature of the place is a kind of experience, an amalgam of memories. The building is already made of experience, both in stain, sweat and social investment.

JL *What are you doing with this 'experience'?*
RH Crystallising the interior of one of the flats is an odd thing to do of course. It's negating a space which contained an experience which we have no idea about, no access to. These buildings suggest a life that is spent, they are at the end of something.

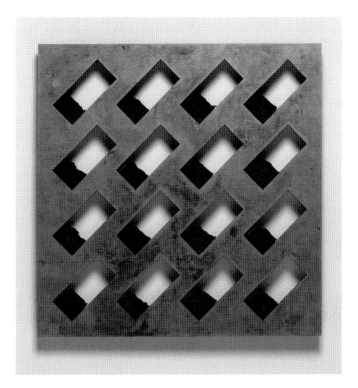

Untitled, 2008. Stainless steel and brain matter

JL *How does this relate to the car pieces? Are they at the end of something too?*

RH Well, yes and no. Partly yes, because without getting too much into Ballard, they are taken from car crashes.

JL *Why was that important?*

RH Because they were much cheaper, the engines were salvaged from wrecks. They were completely fucked-up once useful things. The problem with the people who had these BMWs was that they didn't know how much power they had and couldn't control them.

JL *You mentioned Ballard. Is there an affinity to his writing? One way of looking at your sculptures might be as if they are objects from a future moment in Western culture, that they involve a projection in time as many of Ballard's novels do.*

RH I did read *The Crystal World*, but actually some time after I'd started working with crystals. I like the fact that the language is straightforward, there's no mystery. The aspect of Ballard that I really like is that he found the gaps, the places that no-one else was particularly interested in – out-of-town shopping malls, motorway underpasses, high-rise buildings. It's a sort of psycho-scape that I have an affinity for, and which I know well from growing up in Birmingham.

In London I live in a concrete heaven. The choice of Harper Road has to do with this aesthetic.

JL *Does the crystal overwhelming the object, in this case a bedsit, involve some kind of temporal projection?*

RH I guess there's a certain familiarity with the feeling you get in science fiction. To be sure, the crystallisation is very real, its process is not a simulation or a representational effect. It's experience is an immediate one, though one tempered by the fact that this process is unending, the crystal will grow universally without limit if the environment is maintained. It's the public that corrupts that possibility. The event in terms of the temporal is instantaneous.

JL *A crystal experience – for example in a cave or a grotto – would normally be related to something which has grown over a long period of time.*

RH Something pre-human, something beyond our experience, that's very interesting and useful. This project is of course a synthetic environment; we're forcing the material and a mass of chemicals to do what it does, to create an environment for us. To encourage a material against its world. Instantaneous and without history.

JL *Why is it so important that this material performs according to its own logic?*

RH Because I disappear. These objects become autonomous; they are not mine any longer.

JL *There's a paradox, because at the same time you relinquish control and disappear, you also reappear because of your association with this way of working, with the process, with the material.*

RH Exactly, that's when it's time to move on. We have to be very careful about the way the world works right now, the production aesthetic, which then generates the desire for more production. I'm considering the artist as a possibility for dematerialisation and I don't think an artist should support the status quo, or contrive a consensus with their surroundings.

JL *Would you have liked the crystal growth to have overwhelmed the architecture rather than being contained within it?*

RH When we first talked about the project, there was the idea of submerging a building in its entirety, which was in reality completely ridiculous and maybe too much of an exterior operation, but it's still ridiculous on this scale. The scientists we've been talking to have been taken aback by the scale of the work. The desire to capture

the building, to impregnate it... introducing this strangeness into a functional utilitarian space.

JL You like the idea of seeding and pouring.

RH Maybe there's a psycho-sexual element. In the early days I talked about introducing a liquid in the building, and the host, the environment is seeded, and then the crystal grows out. It's an aggressive process. Maybe it's not so much sexual but to do with the idea of agency, impregnation and growth. It involves the birthing of an object... though I hate the idea of an artist thinking about their objects as babies, it's so self-regarding. I want to push that away. What we are offering is an unusual object in the nature of objects. The negative void into which the liquid is being poured will gradually be reduced. I consider that a rather strange, beautiful sculpture in itself, this brooding chemical mass within a building. The work as a void-filler, it replicates itself unendingly.

JL *The exterior not being crystallised is now important, because it doesn't disclose the interior activity?*

RH It would have involved too much composition, but there will be some natural residues, some very real stains.

JL *So the evidence of the pour isn't important to you. It's not like Jackson Pollock, or Robert Smithson's* Glue Pour *or* Asphalt Rundown, *which were in a way mimicking geological events, where the action itself, the evidence of the action, was very important.*

RH For me, the pouring is a means to get the liquid in, to violate the place. To violate the building's identity.

JL *There's a potential failure here, because you can't gauge how the crystals are growing.*

RH We can only do it once. We're doing it to see how the environment will end up. It's a new form of production, a different way of making, putting these elements together and seeing what happens. That's not a disclaimer if we end up with a flat full of silt, but the environment is a huge amplification of the way that I've worked up to now. It's not about the lack of control. Having more control, that somehow is the big fear of the work, the big fear of all of the work.

London, 24 July 2008

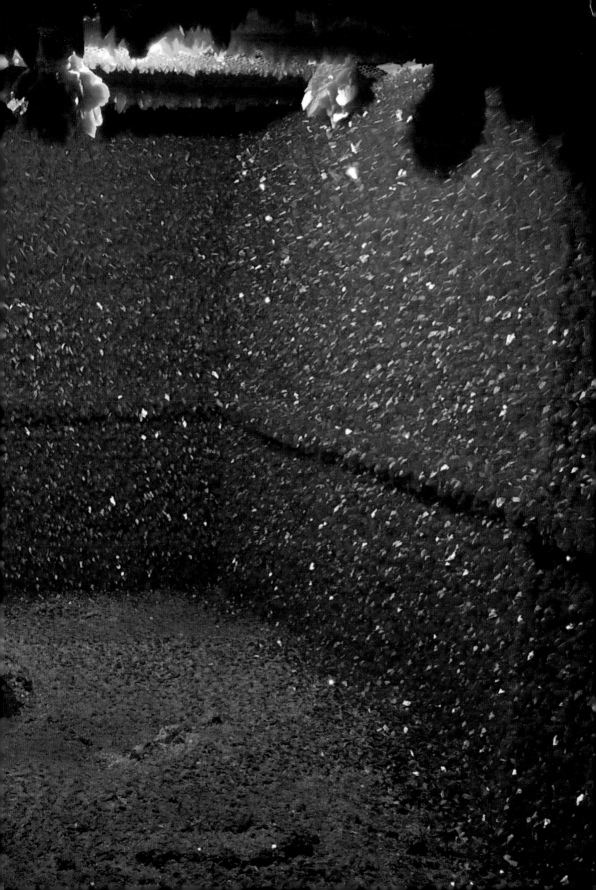

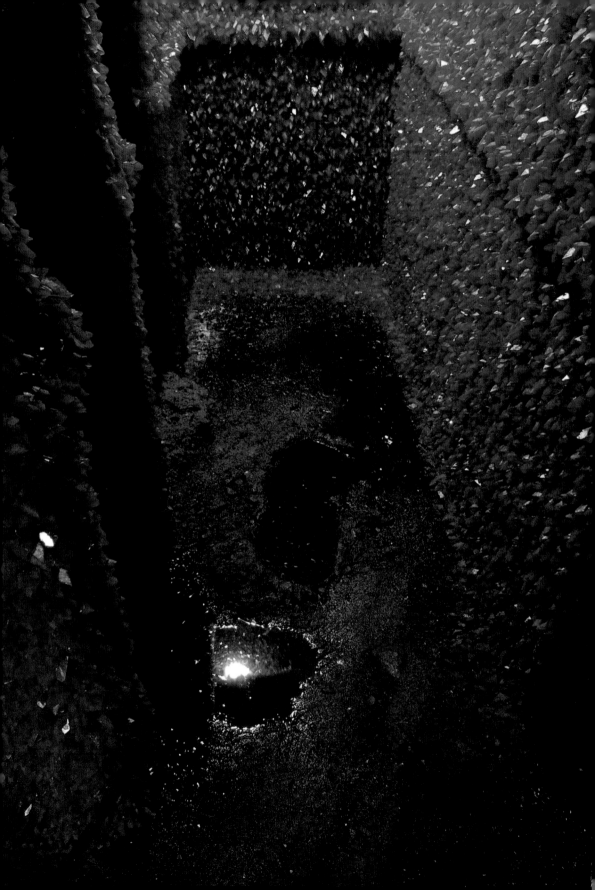

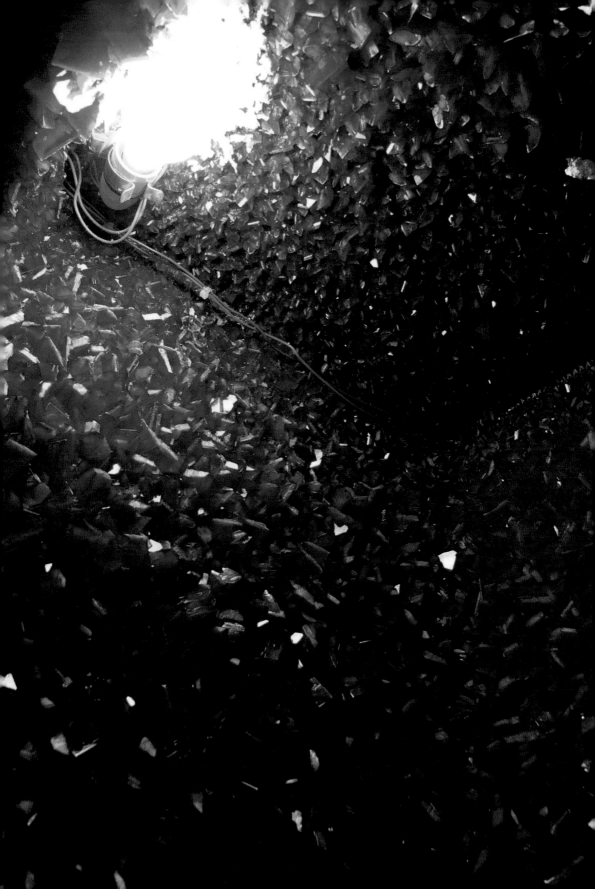

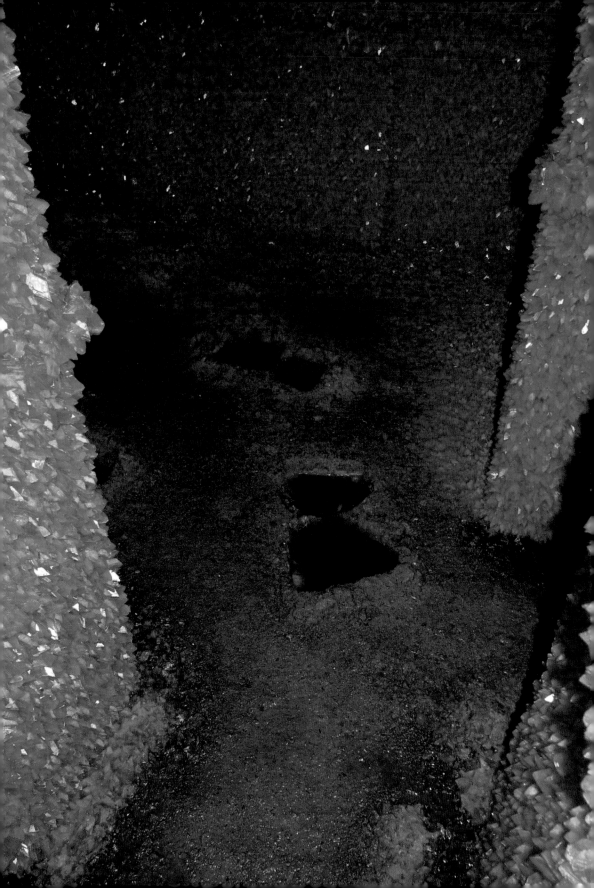

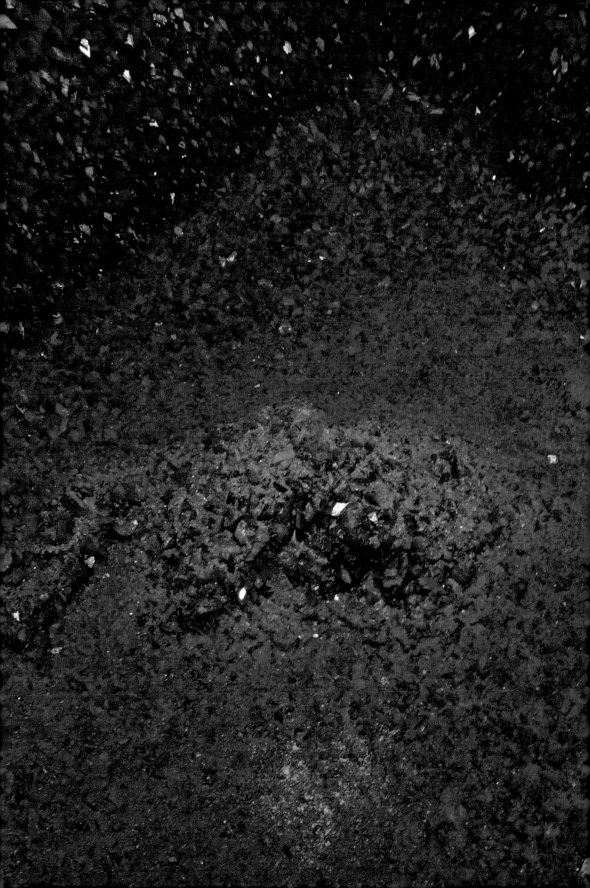

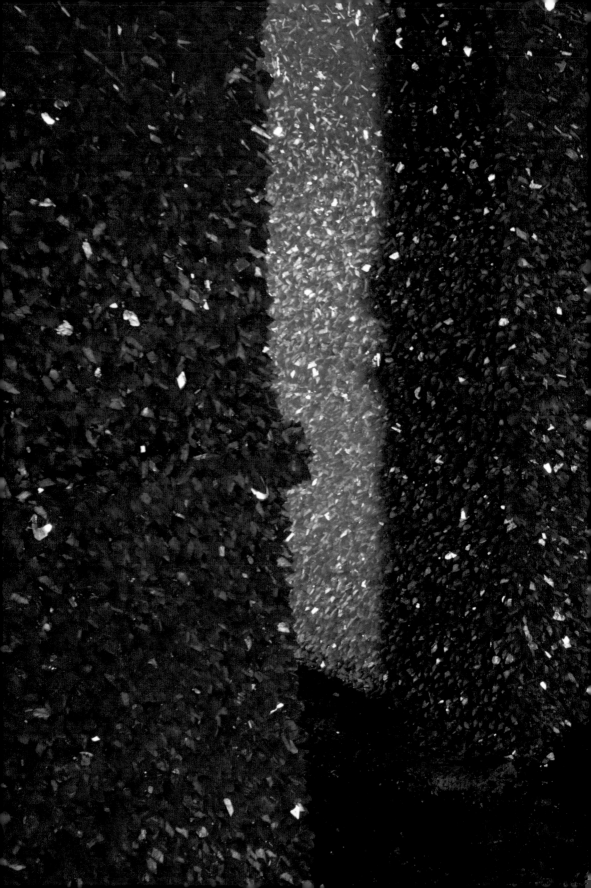

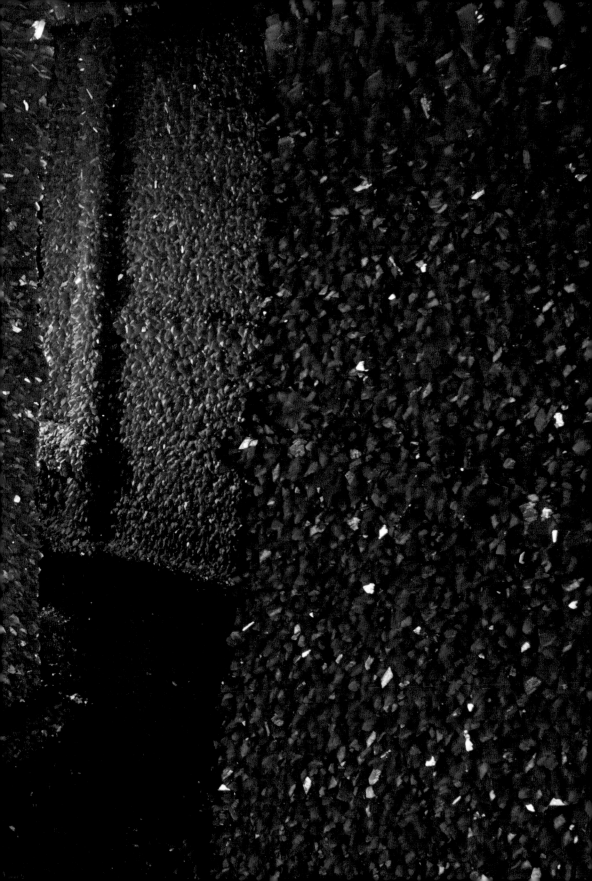

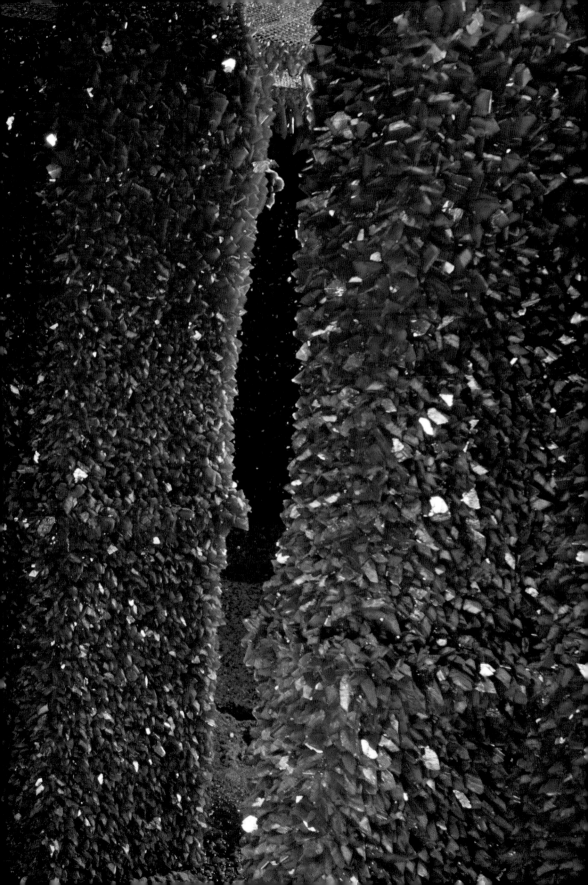

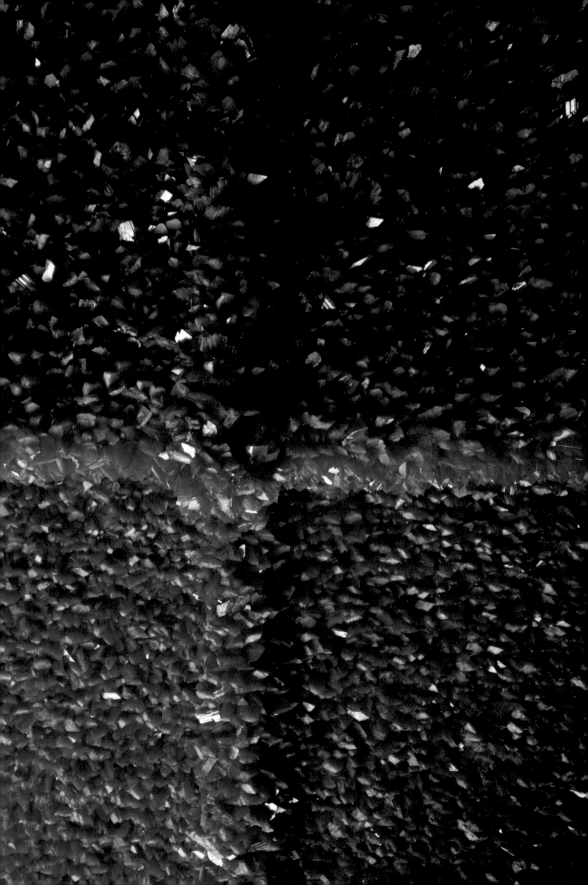

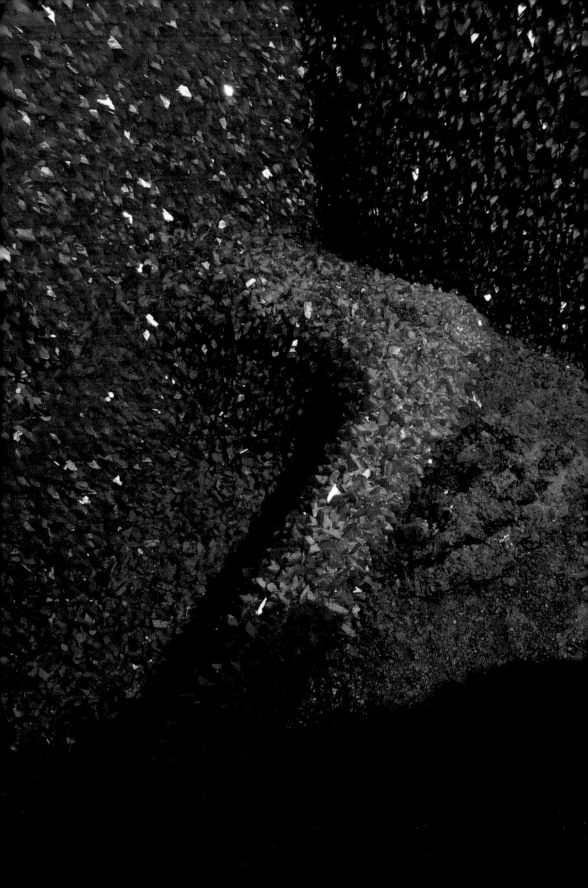

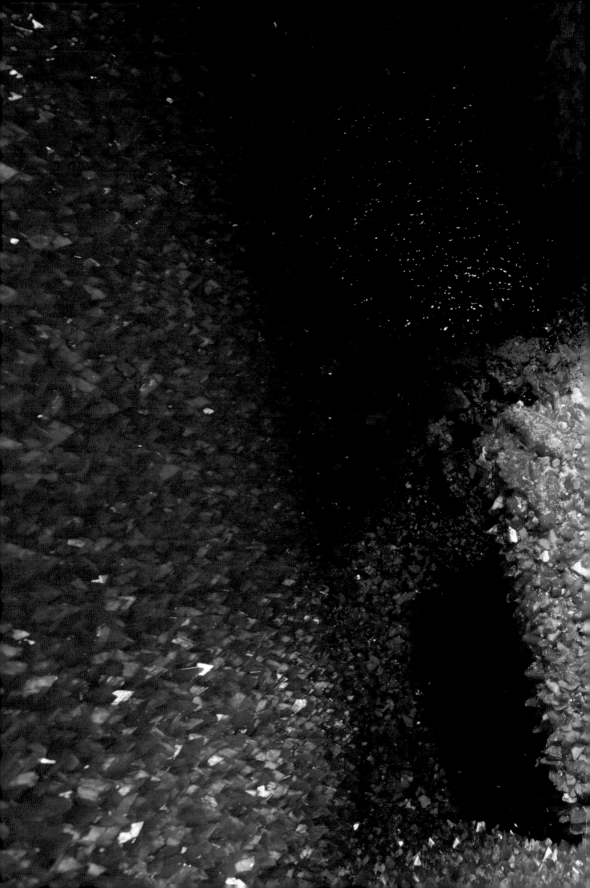

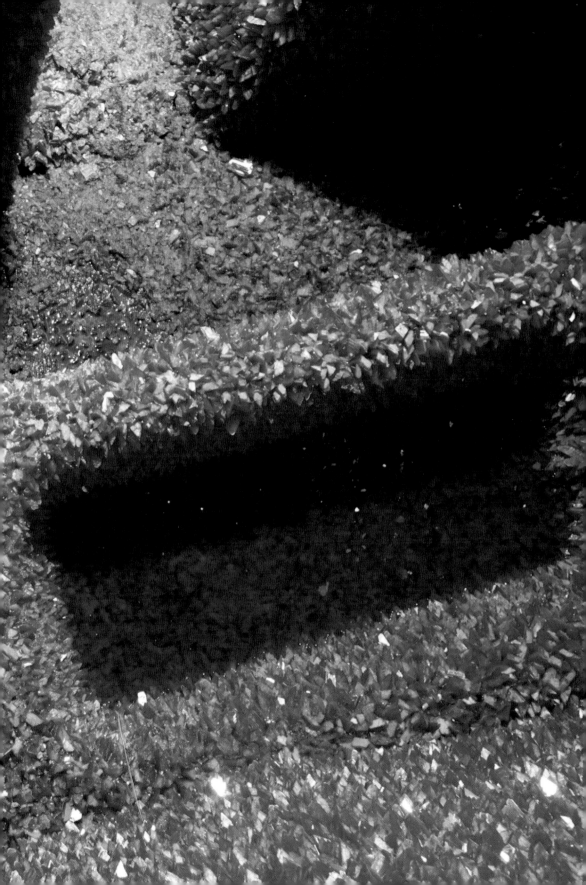

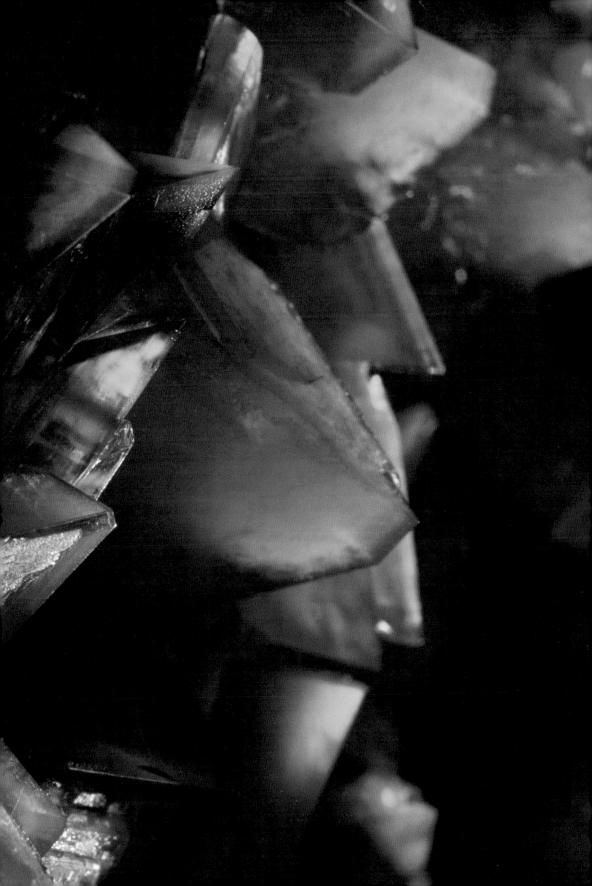

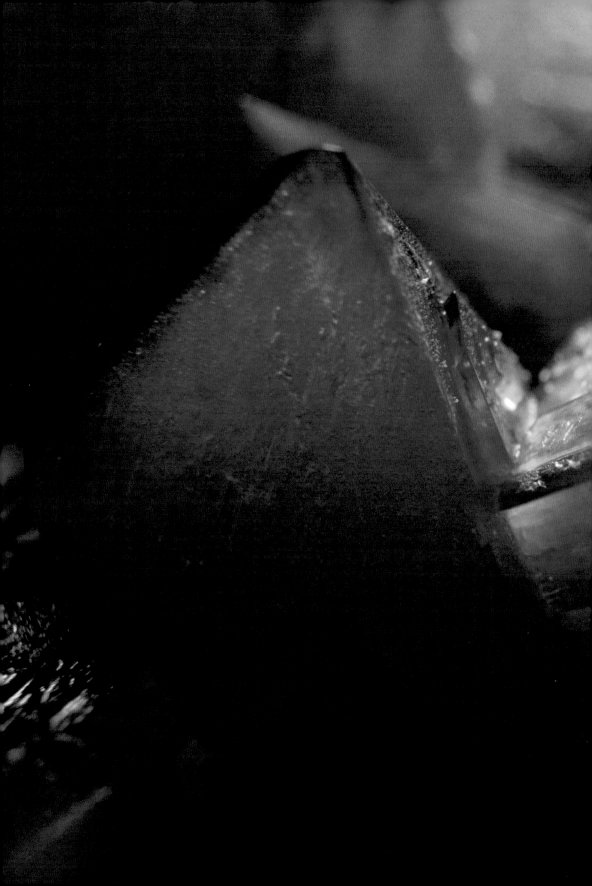

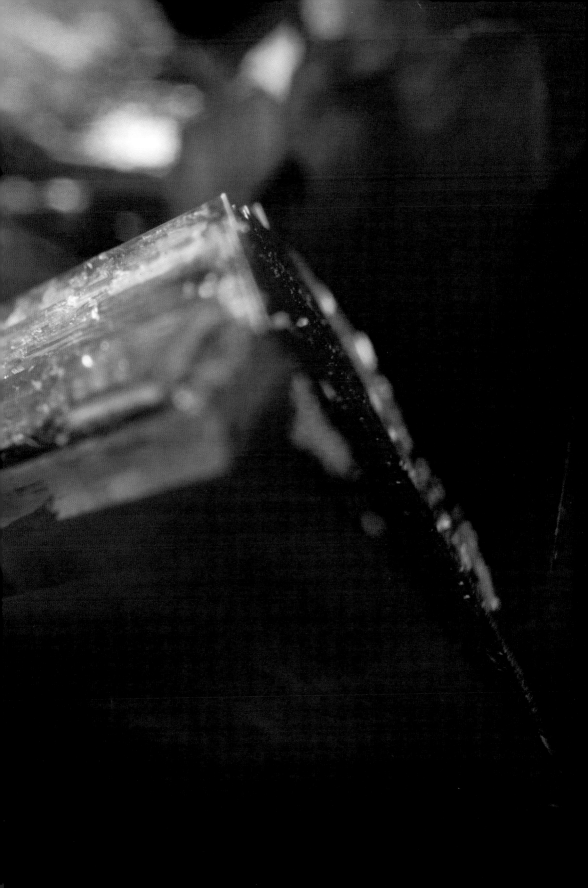

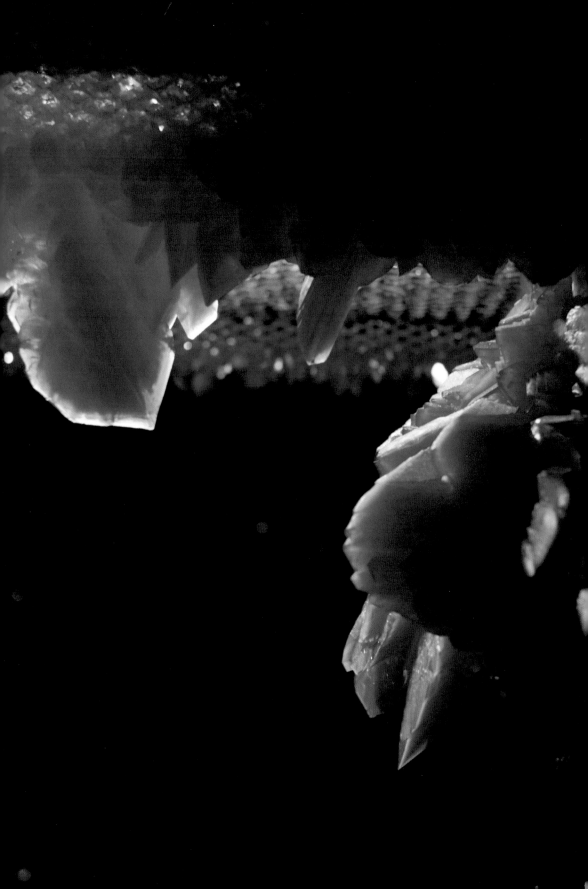

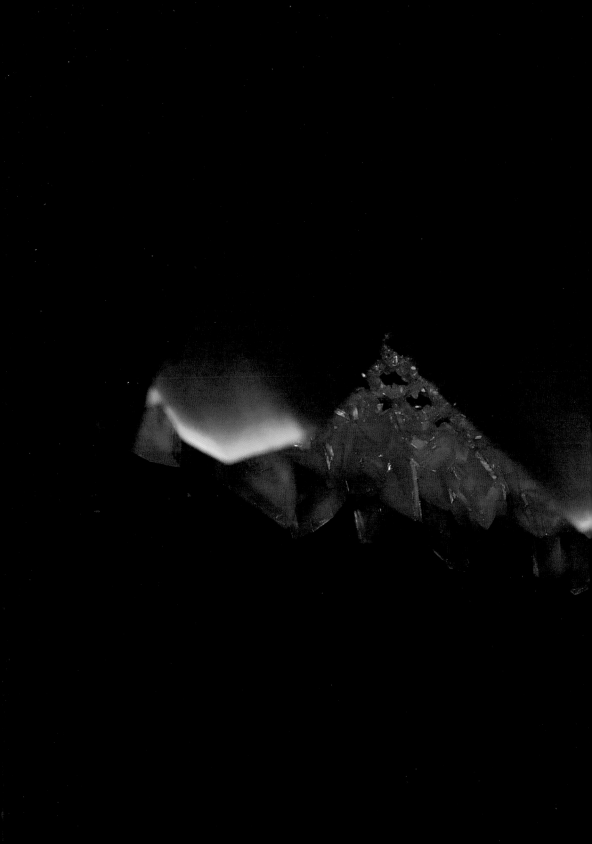

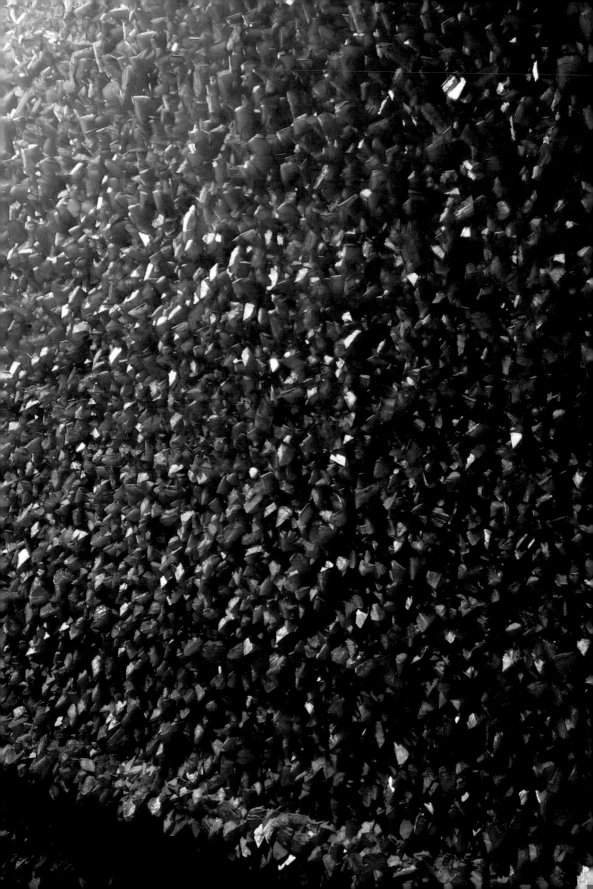

ROGER HIORNS

Born in Birmingham, 1975
Lives in London

1991–3 Fine Art Foundation, Bournville College,
 Birmingham

1996 BA Fine Art, Goldsmiths College, London

Solo exhibitions

2008 *Seizure*, Harper Road,
 Artangel/Jerwood Commission, London
 Corvi-Mora, London

2007 The Church of Saint Paulinus, Richmond,
 North Yorkshire
 Camden Arts Centre, London
 Marc Foxx, Los Angeles

2006 Cubitt, London
 Milton Keynes Gallery, Milton Keynes
 Galerie Nathalie Obadia, Paris
 Corvi-Mora, London

2005 *Benign*, Frieze Projects, London

2003 Corvi-Mora, London
 UCLA Hammer Museum, Los Angeles
 Art Now, Tate Britain, London
 Marc Foxx, Los Angeles

2001 Corvi-Mora, London

Selected group exhibitions

2008 *A Life of Their Own*, Lismore Castle Arts,
 Co. Waterford, Ireland
 Busan Biennale, Busan, Korea
 *Thyssen-Bornemisza Art Contemporary
 as Aleph*, Kunsthaus Graz,

2007 *If Everybody Had an Ocean: Brian Wilson,
 an Art Exhibition*, Tate St Ives, St Ives;
 CAPC Musée d'art Contemporain, Bordeaux
 Handsome Young Doctor, Cubitt, London
 Destroy Athens, 1st Athens Biennial, Athens
 You Have Not Been Honest, MADRE, Naples

2006 *How to Improve the World: 60 Years of
 British Art*, Hayward Gallery, London

2005 *British Art Show 6*, BALTIC Centre for
 Contemporary Art, Gateshead
 The Way We Work Now, Camden Arts
 Centre, London
 ETC, Le Consortium, Dijon
 Le Voyage Interieur: Paris-London, Espace
 EDF Electra, Paris

2004 *The Fee of Angels*, Man in the Holocene,
 London
 Trailer, Man in the Holocene, London
 Into My World, The Aldrich Contemporary
 Art Museum, Ridgefield, Connecticut
 A Secret History of Clay, Tate Liverpool,
 Liverpool
 Particle Theory, Wexner Center for the Arts,
 Columbus, Ohio

2003 *Hidden Agenda or Hide and Seek*, ACME,
 Los Angeles
 New Work, Corvi-Mora, London
 Architecture Schmarchitecture, Kerlin
 Gallery, Dublin

2002 *Still Life*, Museo Nacional de Bellas Artes,
 Santiago, Chile; and tour
 The Dirt of Love, The Mission, London
 Shimmering Substance, Arnolfini, Bristol;
 Cornerhouse, Manchester

2001 *Looking With/Out*, Courtauld Institute
 of Art, London
 Modern Love, Hobbypop Museum,
 Düsseldorf

2000 *Shot in the Head*, Lisson Gallery, London
 "...comes the spirit", Jerwood Gallery, London

1999 *newBuild*, Platform Gallery, London
 Heart and Soul, 60 Long Lane, London

1998 *Resolute*, Platform Gallery, London
 Micro, Hales Gallery, London

1997 *Olympic Village*, Transmission Gallery,
 Glasgow
 European Couples and Others,
 Transmission Gallery, Glasgow

ARTANGEL

Artangel is generously funded by

Arts Council England

and the private patronage of

Artangel International Circle
Inge & Cees de Bruin
The Cranford Collection
Andrea & Guy Dellal
Marie & Joe Donnelly
Tania & Fares Fares
Mala Gaonkar & Oliver Haarmann
Jennifer McSweeney
Catherine & Franck Petitgas
Pascale Revert & Peter Wheeler
Cora & Kaveh Sheibani
Manuela & Iwan Wirth
Anita & Poju Zabludowicz
Michael Zilkha

Special Angels
Michael Aminian
Ivor Braka
Laura & William Burlington
Maryam & Edward Eisler
Elizabeth Kabler
Sarah & David Kowitz
Mary Moore
Kadee Robbins
Hannah Rothschild
Maria & Malek Sukkar
Helen Thorpe
Helen & Edward White
Alasdhair Willis

The Company of Angels